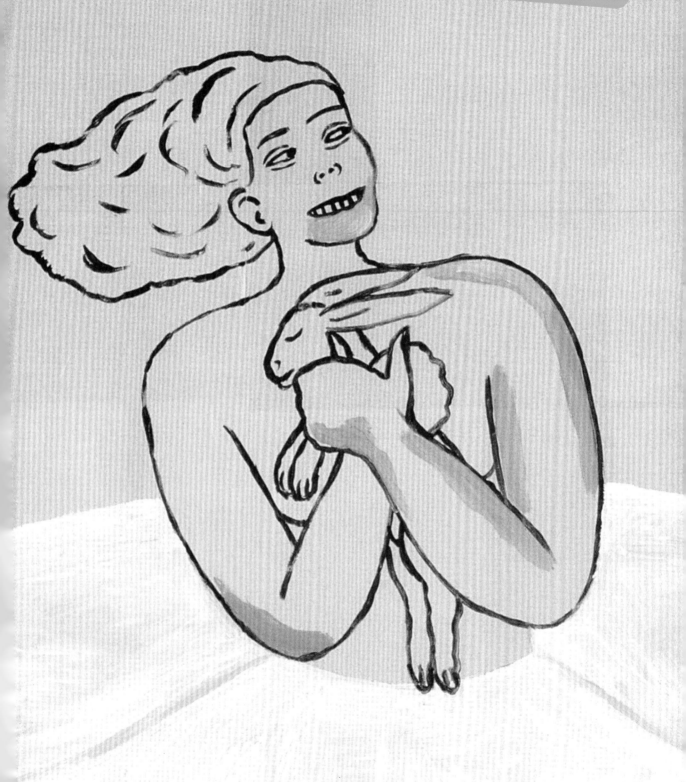

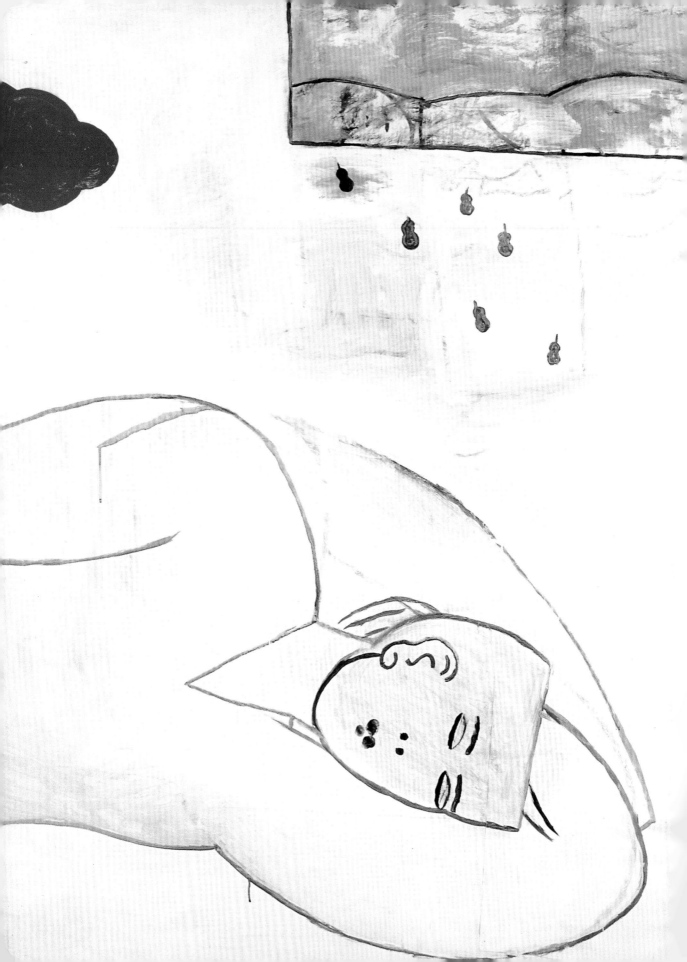

Fay Jones

Sheila Farr

Grover/Thurston Gallery
and
Laura Russo Gallery

in association with
University of Washington Press
Seattle and London

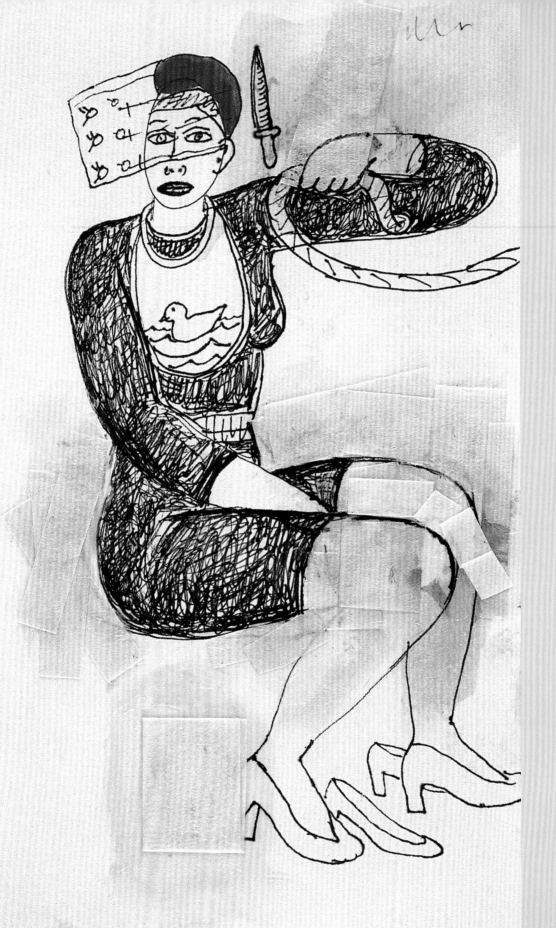

Hair, 1996

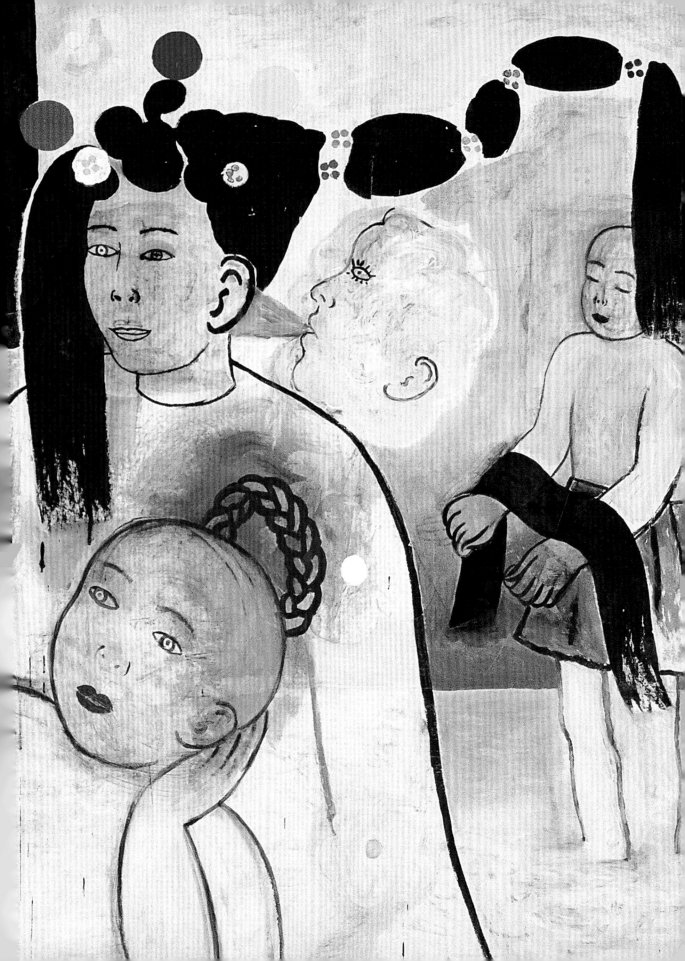

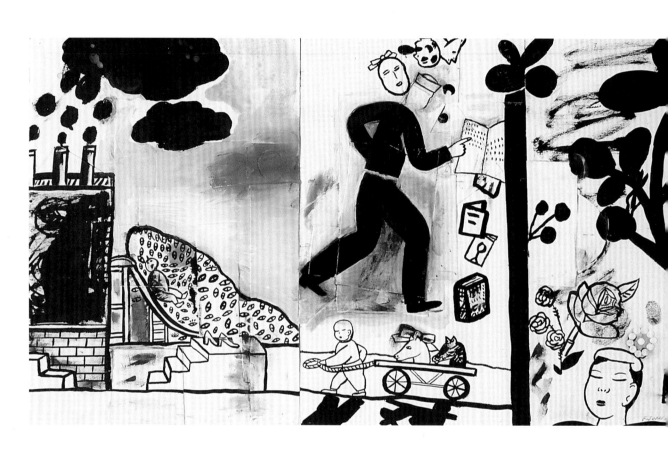

The Cart Beneath the Horse, 1991

Cart Beneath the Horse

The thumb-worn *Webster's New World Dictionary* in Fay Jones's studio isn't just the place to find a definition or look up the proper spelling of a word. For Fay, the book is a captive and tangible muse. Sometimes, to get started, she selects a word and casts it out like bait into her subconscious, and before long, others start roiling to the surface—*handy, red-handed, sleight of hand, handsome*. Along with drawings and doodles and scavenged imagery, her notebooks are full of wordplay. Because Fay's paintings are figurative and evocative, she often gets categorized as a "narrative" painter; but that description is inexact. The work is suggestive, making it easy for viewers to imagine their own possible story lines to explain it. The images, however, are not so prosaic.

T. S. Eliot once said that good poetry communicates before it is understood. The same can be said about Fay's paintings. Even before we sort them out logically, the images pass along a message that can be at once funny, profound, and a little chilling. Explaining the work is like paraphrasing a poem: once you've reduced it to prose, you've lost the rhythm, rhymes, harmonies, wordplays, the multiple implications—all the things that make it what it is.

Fay grew up in an exceptionally literary environment, which early on helped cultivate her poetic imagination. Her father, Robeson Bailey, taught writing, and served on the original faculty of Bread Loaf, the acclaimed summer English program of Middlebury College known for its long association with Robert Frost. Robeson's great-grandfather, Gamaliel Bailey, was editor of the abolitionist newspaper *The National Era,* in Washington, D.C., which first published, in serial form, *Uncle Tom's Cabin.* Robeson married Hester Fay in 1931; during the next eighteen years the couple had six children.

For the Bailey children, keeping company with poets like Robert Frost, Louis Untermeyer, and John Ciardi, or writers such as A. B. Guthrie and Wallace Stegner, was nothing out of the ordinary. They were simply friends of the family. Fay's godfather was the poet Robert Hillyer. The things she remembers about her parents' friends are typical of a child: "John Ciardi didn't like me at all. He liked my sister Kate"; or "Dorothy Parker gave me a toy Scotty dog."

Fay, the oldest child, was born in Boston in 1936. Precocious and strong-willed, she skipped fourth grade and graduated from Northampton High School before she turned seventeen. She always got good grades, so when Fay began failing her junior-year French class, she was called in by the principal. Asked what was going on, she explained her problem: she didn't respect the teacher. The way the principal responded made a big impression on her. He first agreed that the French teacher in question wasn't the best, and explained that she had been hired during the war when it was hard to get qualified people. But he also pointed out that life was going to be full of people who weren't particularly good at their jobs and that it was up to Fay to do her best anyway. Because he was honest and treated her as an adult, the lesson stuck. "It gave me a clue from outside that I had to expect things of myself," Fay recalls.

The Bailey family moved around a fair amount as Fay's father accepted un-tenured teaching jobs at various colleges—Smith and the University of Oregon,

among others. In 1950, her parents bought a small hotel in Williamsburg, Massachusetts, just eight miles from Northampton. Fay remembers that family life changed dramatically. Her father continued teaching—at Rutgers, the University of Massachusetts, and eventually the University of Delaware—but her mother now worked eighteen-hour days to keep the hotel and six children running on schedule. Fay helped by caring for her younger sisters and brothers. She also worked in the hotel kitchen, where she made friends with the other employees. There, from the cook, Dave Ring—Fay calls him "my earliest mentor"—she learned, among other things, how to skin a muskrat and spot a phony. Dave, Fay recalls, was an uncanny judge of character. Years later, when Fay was home visiting from art school with her boyfriend, Bob Jones, Dave spotted them necking in a corner and good-naturedly prodded Bob. "Are you as dumb as you look," he wanted to know, "or are you going to marry her?" Bob took the cue.

Growing up, Fay was very close to her maternal grandmother, also named Hester, who lived in Cambridge with her husband, Richard Fay, an electrical engineer and underwater acoustician. Whenever Fay visited, her grandmother would take her to the Boston Museum of Fine Arts and to Harvard, to see the Ware Collection of glass flowers at the Botanical Museum. They went to the movies together. Fay recalls, during the mid-'40s, watching a newsreel of European refugees and having her grandmother burst into tears, and then drag her out of the theatre. Many years later, when Fay began her career as a painter, it was her grandmother who served as her mentor, a constant source of emotional support. "My grandmother really trained my eyes," Fay says. "She painted these great loose watercolors and had a drawer of paints and papers and sealing wax that we were allowed to play with. She always encouraged art. But more than that, she encouraged observation."

From an early age, Fay knew she wanted to be an artist. "I always drew all the time," she says. "I didn't think about it, I just did it." But the real revelation

came when a family friend, Inga Pratt, gave her a Grumbacher watercolor set. Inga's husband, Fletcher, a naval historian and writer on the Bread Loaf faculty, had coauthored the cookbook *A Man and His Meals* (originally called *From Hoof to Mouth*) with Fay's father. Inga was an illustrator for the department store Lord & Taylor. The Pratts had no children and lived the Bohemian life in their New York apartment, which Fay remembers being furnished with "monkeys and bongo drums." Fay says when she received the watercolors—a full range of colors packaged with two sable brushes in a beautiful silvery metal box—"I was eleven years old and that was it. How did she know? It was as if I'd been reading children's stories and suddenly somebody gave me an adult book."

After graduating from high school in 1953, Fay attended the Rhode Island School of Design, planning to become a textile designer. By her second year, she had switched her major to painting. Although the biggest art news in those days was abstract expressionism, the RISD curriculum was focused on the past. Fay felt little affinity with French postimpressionism and the academic rules of painting, although she dutifully absorbed them. But when the RISD museum mounted the first major exhibit of Mark Rothko's paintings in 1955, Fay was awestruck. Seeing such extraordinary work didn't make her want to paint like Rothko, she says, but it opened up a realm of possibilities that she hadn't experienced in the classroom. "It made me want to be myself."

In 1956 Fay met Bob, that is, Robert Jones, a drawing instructor at RISD; they married the following year. Their son Tim was born in 1958 and a daughter, Deirdre, in 1960—the year that Bob accepted a job on the art faculty at the University of Washington. Two more sons were born after they moved to Seattle: Tom, in 1964, and Sebastian, in 1966. It was 1970 before Fay, working in a small format, had her first painting exhibit at the Francine Seders Gallery. All her previous work, from art school, she had destroyed.

In the years since then, she has developed a fluid vocabulary of color, a

powerful sense of formal arrangement, and a unique personal iconography, which, though much admired, has never been successfully imitated. Fay doesn't associate with any particular school of painting; she has no concern for how her work fits into the history of art. All that matters is the language of each picture.

Because Fay tends to work automatically and her imagery is characterized by odd juxtapositions, it's easy to see surrealism as her antecedent. She acknowledges the similarities, but lacks any interest in the artistic dogma that was part of the surrealist movement. As a primary influence, Fay cites the big, loose emotional abstractions of Philip Guston. "I fell for those fifties paintings in the Museum of Modern Art when I was in art school. That's what I went to New York to see. They were so alive and *painted* and unexpected . . . and when he 'turned' [returned to figurative work], becoming the critics' nemesis, it seemed perfectly natural to me. Those last paintings, which I saw in his retrospective, had everything."

The French poet Paul Valéry, attempting to define his art form, describes an extraordinary condition he calls "a state of poetry." He says it is "completely irregular, inconstant, involuntary, and fragile and . . . we lose it, as we find it, by accident." For Valéry, that "state of poetry" isn't just a synonym for the muse. He believed that the job of the poet—and other artists as well—is not just to experience the poetic state but to induce it in others. The highest function of art, in other words, is to inspire its audience.

During the thirty years she has been exhibiting on the West Coast, Fay has become one of the region's most esteemed artists. With their beauty and insight, her paintings have the rare ability to satisfy sophisticated curators and collectors, and still charm the general public. Fay's work is especially appreciated by the most discerning audience of all: other artists. Rife with signs and pregnant with ambiguity, chanting and rhyming and divining like twenty-first-century Sibyls, Fay's paintings can induce a state of poetry in anyone who sees them.

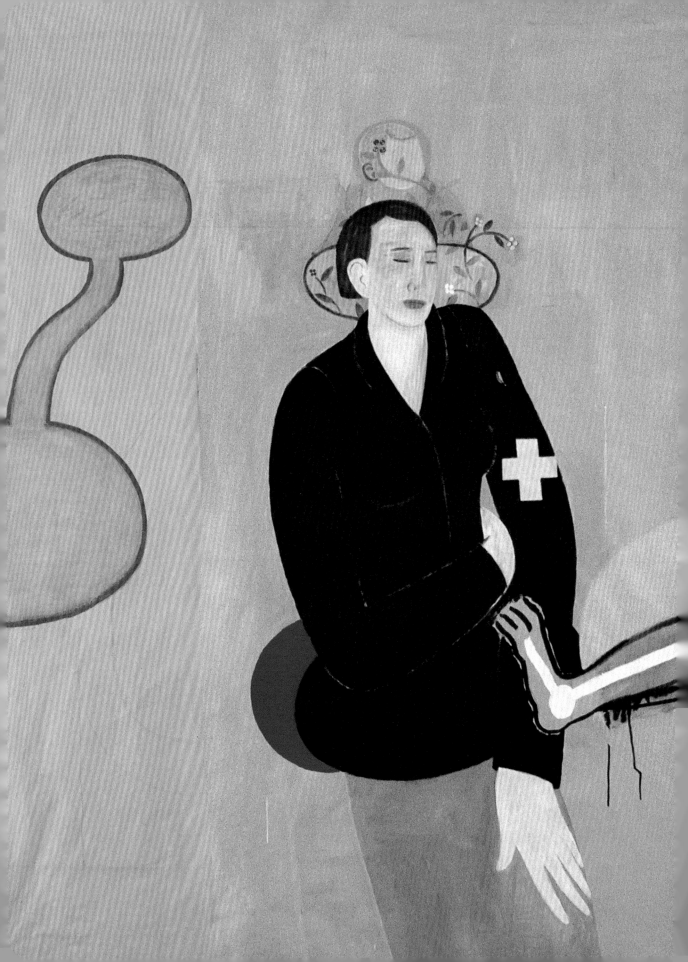

Caution, 1997

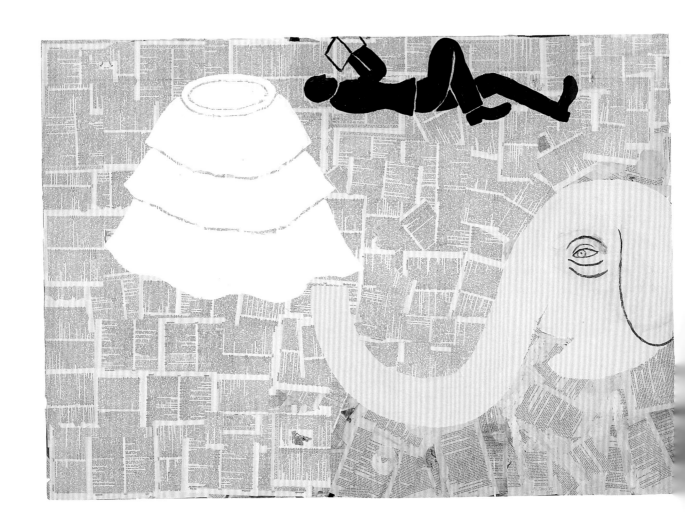

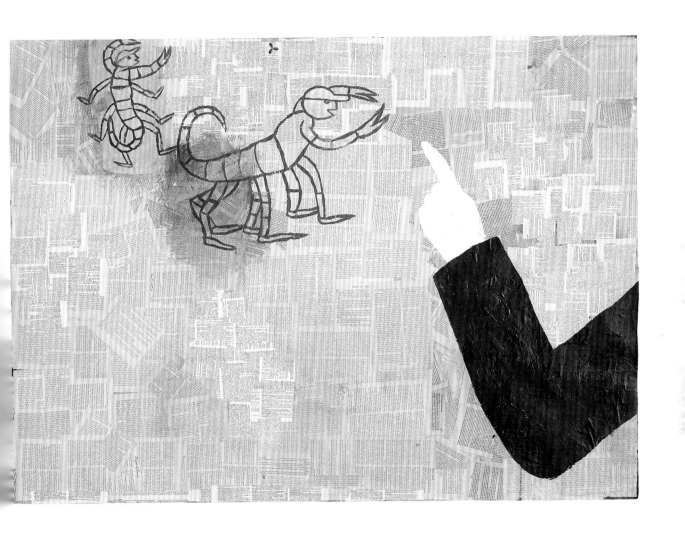

Dysphoria, 1997

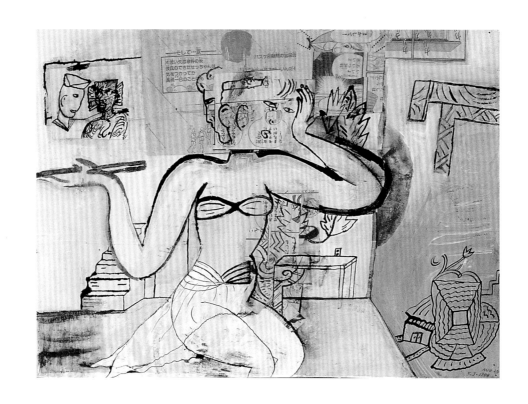

Dolce Far Niente, 1988

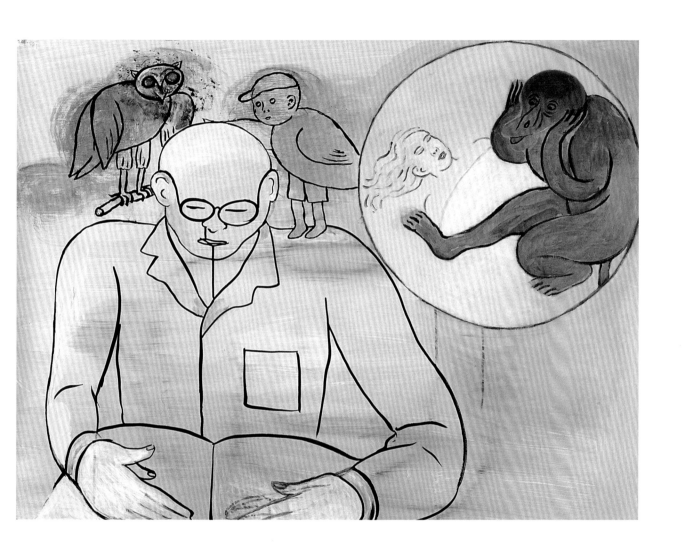

Diagnosis, 1997

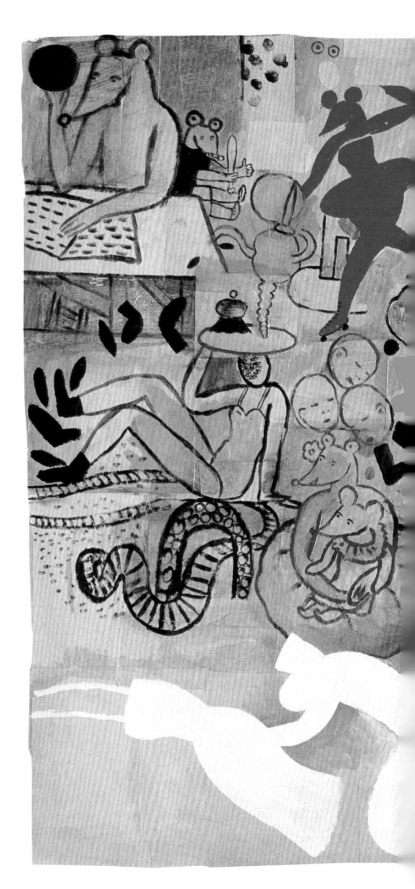

Two Pools: Riddle and Ghosts,
1992

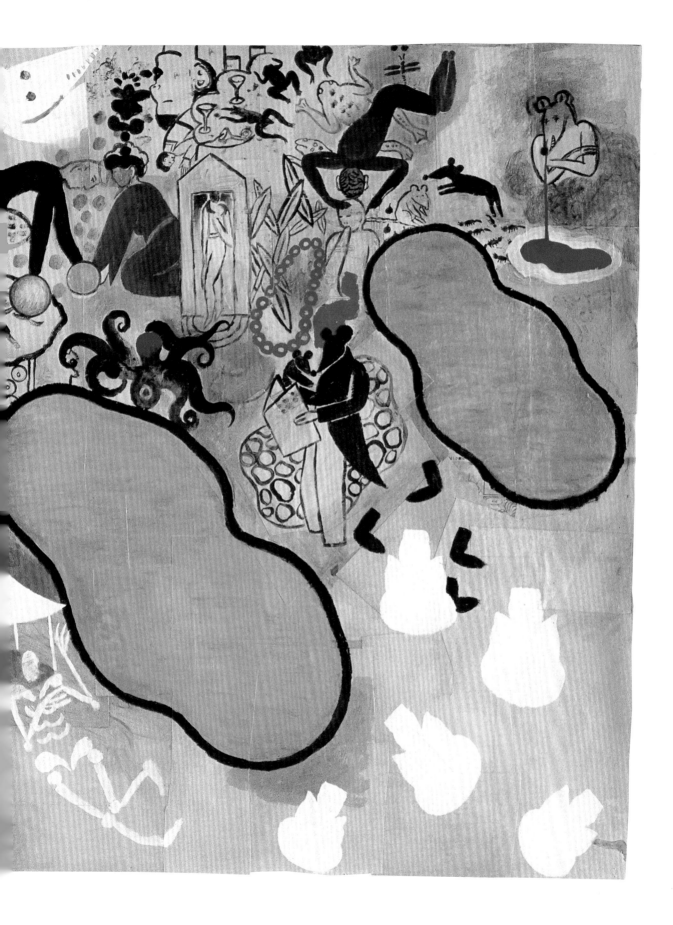

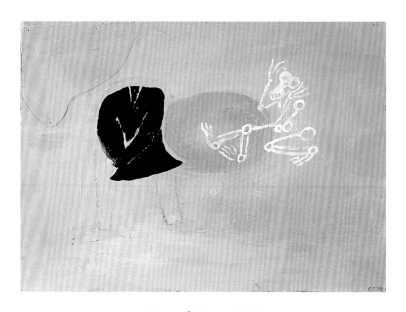

Coat and Bones, 1997

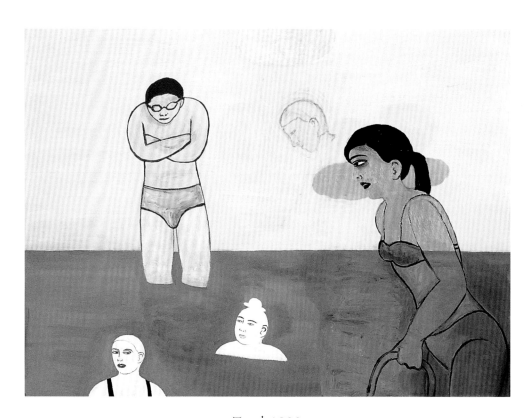

Travel, 1999

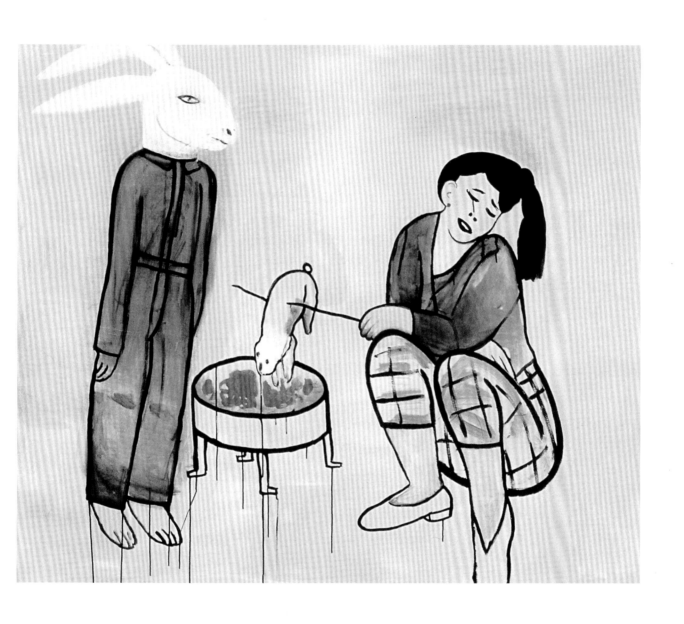

Meat, 1996

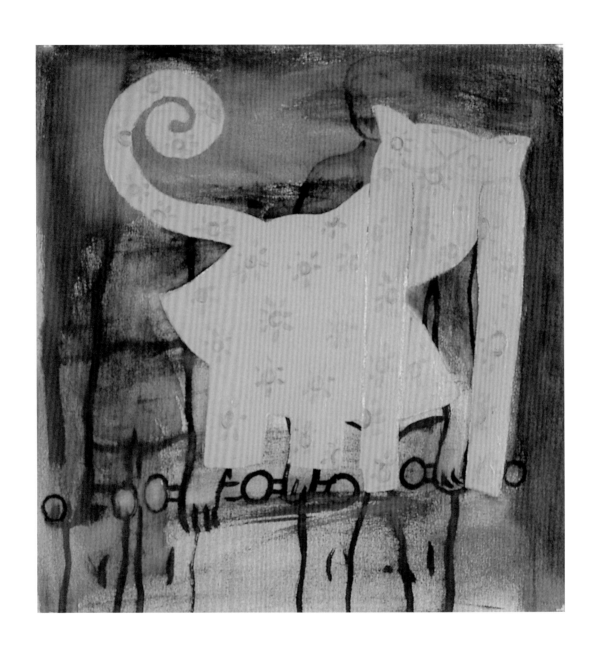

Blue Monkey Dress, 1997

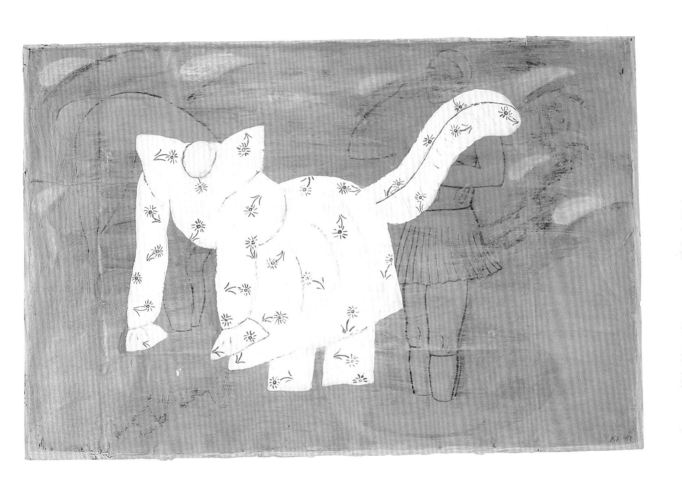

Monkey Dress, n.d.

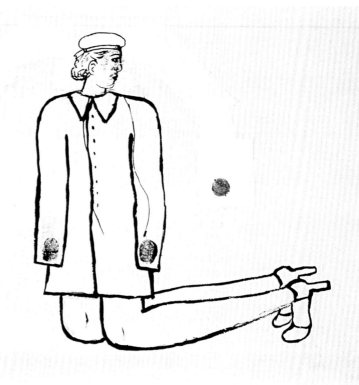

Kneel, 1996

Dress and Suit Adjacent, 1997

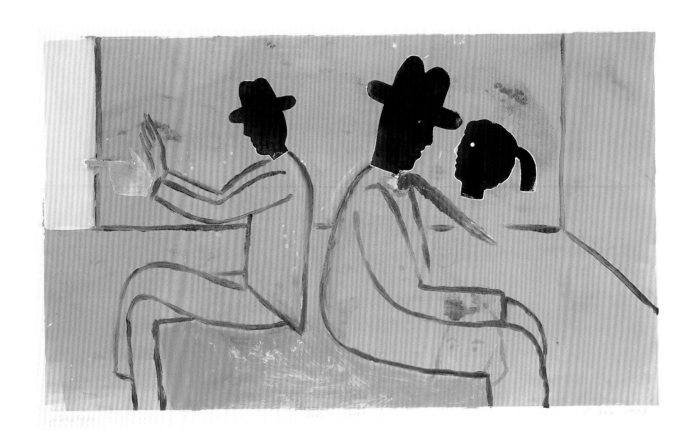

Court Date, 1993

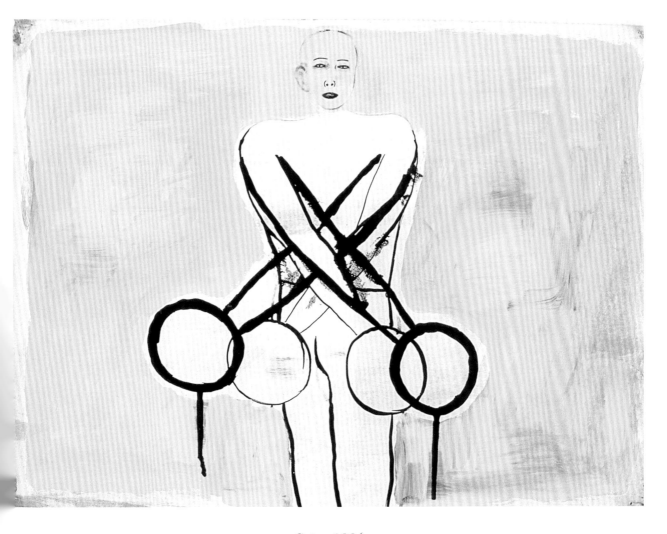

Swing, 1996

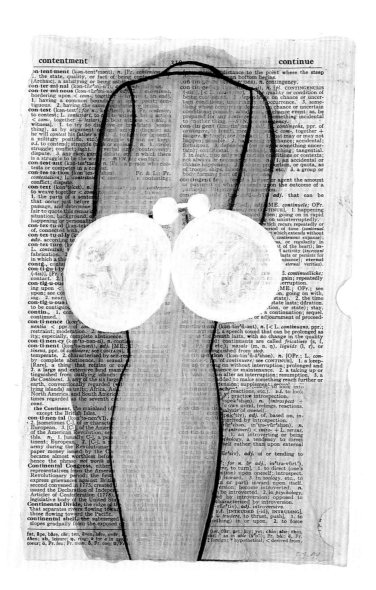

Contentment/Continue, 1994

(A)

Fay Jones's Favorite Books

Fay made this list quickly, at the request of an education curator at the Boise Art Museum, the night before her retrospective opened there in 1996. She decided not to amend it, but to leave it as is: a spontaneous reflection of her reading habits that reaches back more than fifty years.

Diane Ackerman, *A Natural History of the Senses*

Saul Bellow, *The Adventures of Augie March*

Heinrich Böll, *Irish Journal* and *Billiards at Half-Past Nine*

Kay Boyle, *Thirty Stories*

Ray Bradbury, *Fahrenheit 451*

Charlotte Brontë, *Jane Eyre*

Elias Canetti, *Auto-da-fé*

Lewis Carroll, *Alice in Wonderland*

Joyce Cary, *The Horse's Mouth, Herself Surprised,*
and *Not Honour More*

Eleanor Clark, *The Oysters of Locmariaquer*

Joan Didion, *The White Album*

Isak Dinesen, *Seven Gothic Tales*

John Gregory Dunne, *Vegas*

Lawrence Durrell, *Bitter Lemons* and *Alexandria Quartet*

Henry Fielding, *Tom Jones*

C. S. Forester, *The African Queen*

E. M. Forster, *Howard's End*

Carlos Fuentes, *Constancia and Other Stories for Virgins*

Kenneth Grahame, *The Wind in the Willows*

John Irving, *Hotel New Hampshire*

Sarah Orne Jewett, *Country of the Pointed Firs*

Jack Kerouac, *On the Road*

Primo Levi, *The Periodic Table*

Gabriel García Márquez, *Strange Pilgrims*

Alberto Moravia, *Two Women*

Flannery O'Conner, *In Wise Blood* and *Collected Letters*

Michael Ondaatje, *Running in the Family*

Marcel Proust, *Swann's Way*

Sam Shepard, *Motel Chronicles*

Alan Sillitoe, *Loneliness of the Long Distance Runner*

J. M. Synge, *Playboy of the Western World* and *Riders to the Sea*

Ivan Turgenev, *Fathers and Sons*

John Updike, *The Centaur*

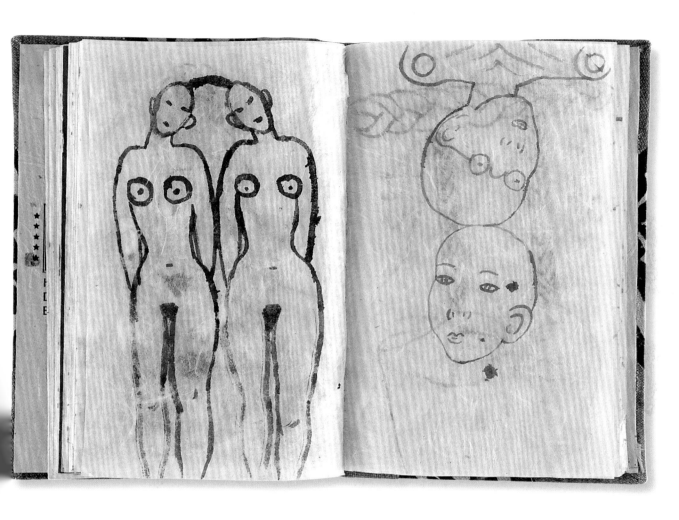

From Notebook XIII

From Notebook IX

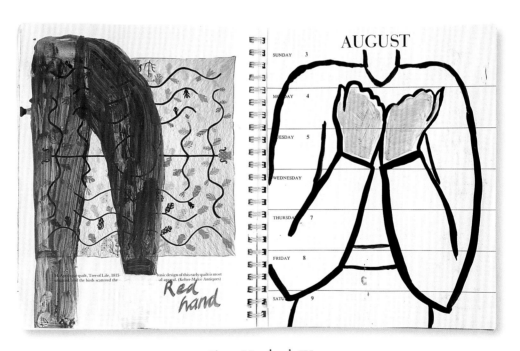

From Notebook IX

From Notebook IX

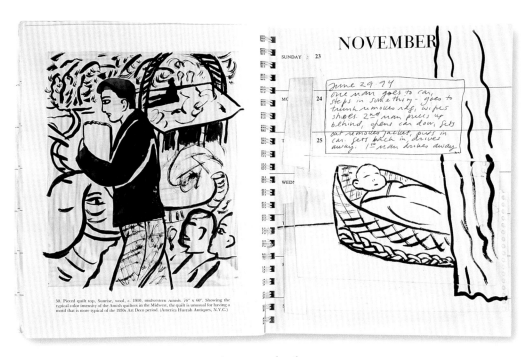

From Notebook IX

From Notebook XII

From Notebook XII

CARD D

NOT AT ALL *BELLIGERENT* . . 1

SLIGHTLY *TELEPATHIC* . . 2

MODERATELY *MELLIFLUOUS* . . . 3

QUITE A BIT *DELICATE*

EXTREMELY *ZEALOUS* . . . 5

ALSO QUERULOUS

From Notebook XII

CARD K

ALWAYS *SAIL AWAY* 1

VERY OFTEN *TAKE THE TRAIN* 2

FAIRLY OFTEN *RIDE THE BUS* . . . 3

SOMETIMES *WALK* 4

ALMOST NEVER *CATCH A FEVER* 5

NEVER *CRY* 6

From Notebook XII

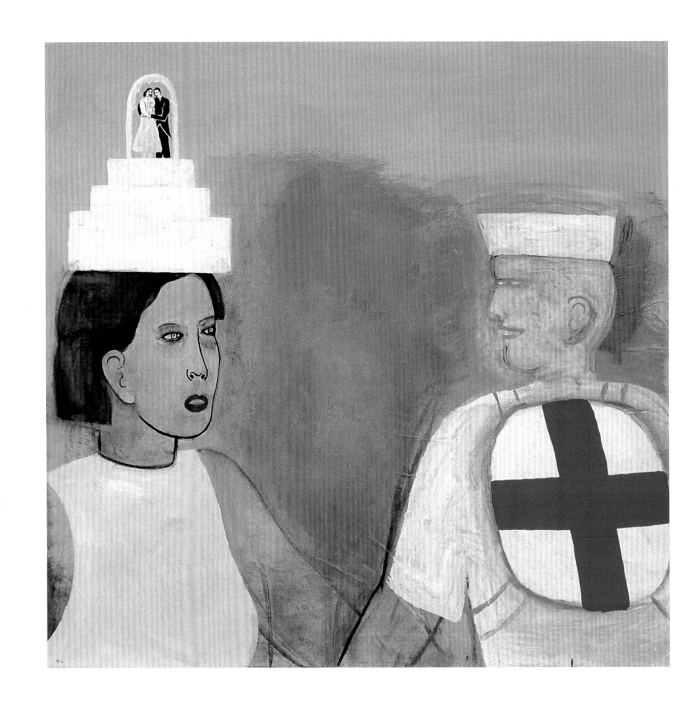

Fog, 1995

Couples/Couplets

The couples in Fay Jones's work exist in a state of symbiosis. They might be connected, as in *Fog* (p. 38), by cloudy vapor between their faces (to shroud motives that are otherwise a bit too obvious), or joined in an embrace, a dance, a kiss, by an exchange of gifts, or some physical apparatus. Some are bonded together like Siamese twins. Fay's pairs recall Meret Oppenheim's conceptual masterpiece *Das Paar* (The Couple; p. 40), a sculptural ode to the crippling power of codependence made long before the term was coined. An early and underrecognized member of the surrealists, Oppenheim was a particularly beautiful woman, and as such was esteemed by her male peers more as a model and muse than as an artist. Nevertheless, she consistently produced superb work, including one of the most potent icons of the movement—the famous fur-lined teacup—which just last year (to prove my point) was mistakenly attributed to Marcel Duchamp by an arts writer for the *New York Times*.

Oppenheim and Jones share a highly intuitive way of relating to their work, and both use symbols that are very much about sex, in the broadest sense: male and female role playing, cross-dressing, courtship rituals, desire, foreplay, intercourse, and psychological interdependence, with its blinders and shackles.

Meret Oppenheim, *Das Paar,* 1956. © 2000 Artists
Rights Society (ARS), New York / ProLitteris, Zürich

Although the imagery often deals in gestures and subterfuges, the obvious mani-festations of desire, it consistently reveals something greater. Consider the col-lage painting *Little Pillow Mates* (p. 50), in which Jones places two heads together, kissing, at the center of a circle. With a single curved and segmented line inter-secting it, like a line of stitching, the circle transforms into an icon that's both a yin/yang symbol and a baseball. The image plays on the perfect union of male and female energy implicit in the Chinese symbol and the blunt colloquialism of "ball." As an aside, it also augurs the lurking presence of Seattle's ballpark, Safeco Field, which sprang up just a few blocks from Jones's studio.

The poignant gesture of *Gifts* (p. 41) in which a man and woman hopefully offer presents to each other, is a wonder of formal poise. Like so many Jones paintings, it divides into two parts; in this case vertically and smack down the center. Each figure takes up the entire vertical reach of the paper: their heads hit the top, their legs reach beyond the bottom of the page and appear cut off at the ankle. But we see that the man's left leg, flung up for balance, actually *is* cut off at the ankle. Is there nothing grounding these two? We are forced to imagine what is below them—whether they are balanced on something or levitating—but

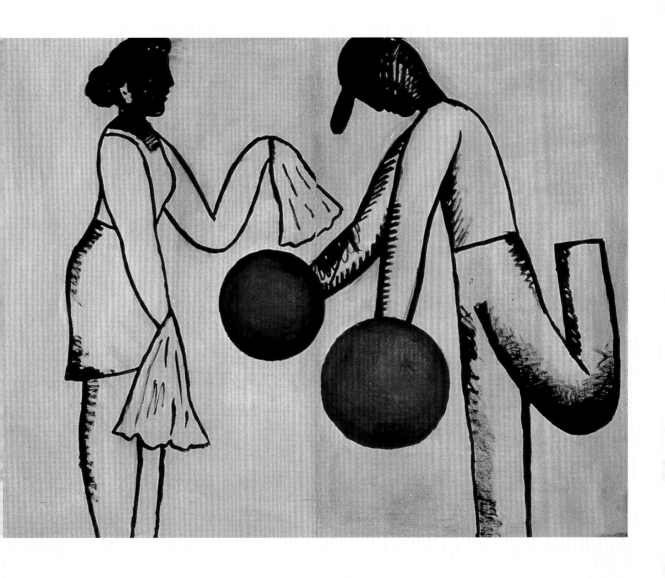

Gifts, 1992

they seem to be divided by a great precipice. It's typical of Fay's imagery that what is absent has as much meaning—sometimes more—than what is shown. She paints the language of the void.

Notice that the figures themselves are empty—just outlines except for their blacked-out faces and a bit of shading. And the man's heavy, bowling ball hands hold the only color in the painting except for the sienna ground of the paper, which pervades both the exterior and interior of the figures. They are red.

In Fay's paintings, color is meaning; and the warm, sun-drenched clay color that is the pervasive environment of the piece is as suggestive of desire as a languorous afternoon in a southern climate. Red, of course, has a vocabulary of its own that's entirely devoted to the quickened pulsing of blood, whether in battle, the bullring, or in bed. The black figures in profile and the accent of red on a clay-colored ground suggest the stylized tableaux on classical Greek pottery, the somnambulist gestures of ancient ritual.

So here are these two people, entombed in their respective halves of the picture, yet reaching out to each other with awkward and futile-seeming signals, one arm up, one down. The image is all motion, like a person trying to balance while standing on top of a ball. It has an asymmetrical symmetry. Two halves of the picture, two figures, four arms, four legs; but instead of the stillness of a mirrored image, we get an ominous sense of movement. The gesture in the image is not complete. Further, and perhaps more extreme, motion is impending.

Motion is suggested by the imagery, while the composition creates its own kind of motion—it carries our eyes in a gracefully snaking path from left to right. We see two implied diagonals that cross left of center in the middle of the upper red circle. Here lies the tension of the composition, the imbalance that seems to be pulling the man forward and down.

Gifts is such an archetypal Jones image that it can be used as a master key to much of her work. It perfectly presents her characteristic dichotomy, both in form and content. It revels in puns and metaphorical wordplay. For here, the two

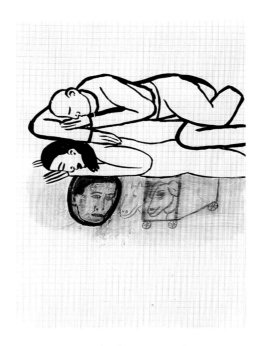

Notebook III #1, n.d.

figures both offer and *are* their gifts: he with his ponderous mitts, like the iron balls attached to slaves or prisoners; she with her fluttering, veil-like *hand*-kerchiefs. The figures are, in a sense, presenting their own *hand*-icaps. One can easily imagine a deep crevasse between these two, just below the picture space, with the man about to topple in, pulled over by the weight of his offering and his own eagerness. Both of their faces are blacked out—they are masked for this awkward attempt at exchange—and their bodies are only outlines. These aren't individuals so much as feminine and masculine ways of being—magnetically drawn to each other but eternally divided.

Another intriguing possibility is inherent in the image: that if one of these gifts is accepted, it will lodge in the receiver like a parasite and irretrievably alter its host. One of those gauzy kerchiefs could attach to the man's face like a veil, stifling him and forever clouding his vision; or an unwieldy heaviness might implant itself in the woman, like a ball and chain, suppressing her will, keeping her eternally anchored to her keeper.

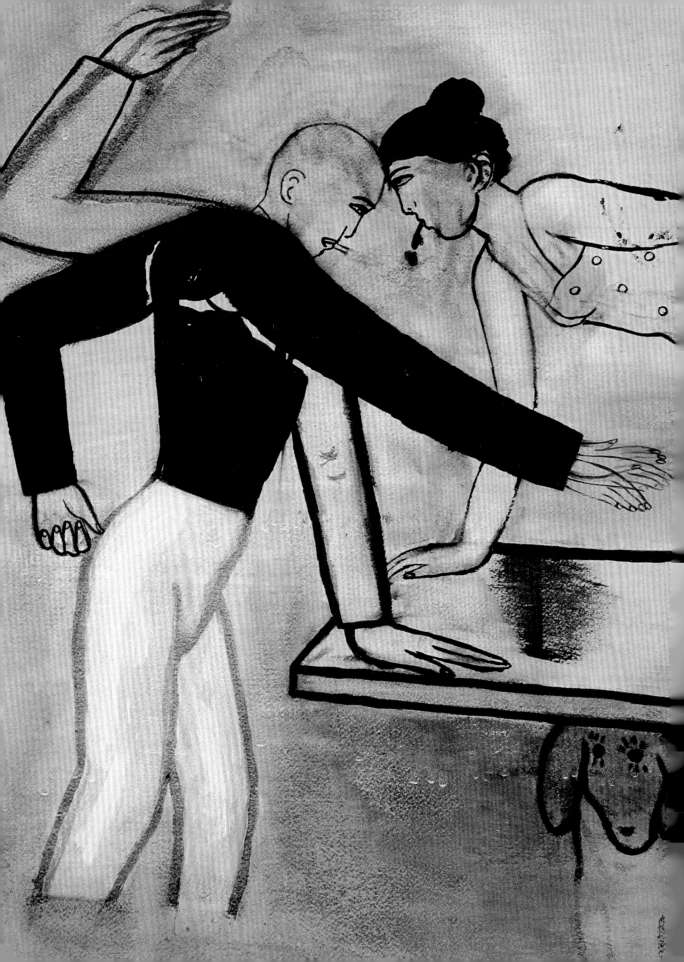

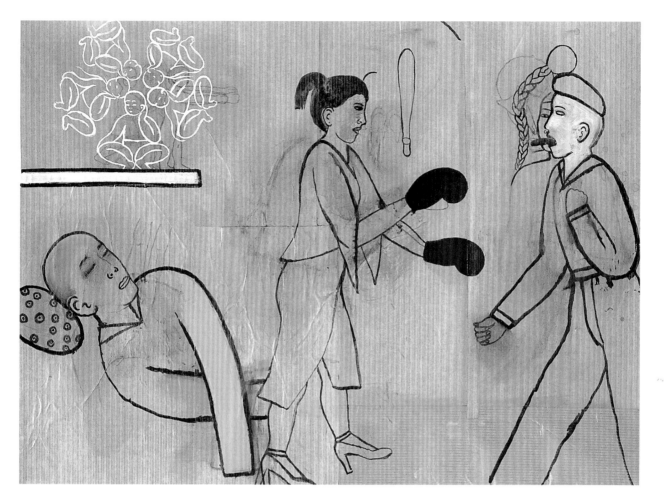

Meet, Sleep, 1996

Props, 1995

Silent Treatment, 1999

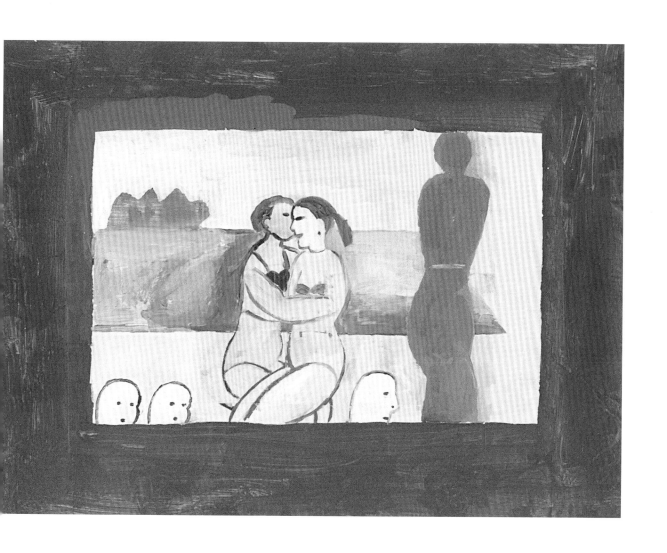

Siblings, 1991

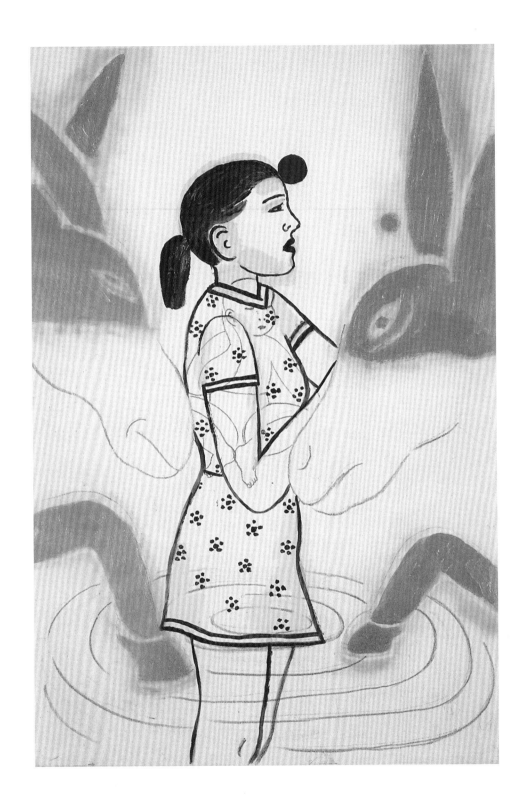

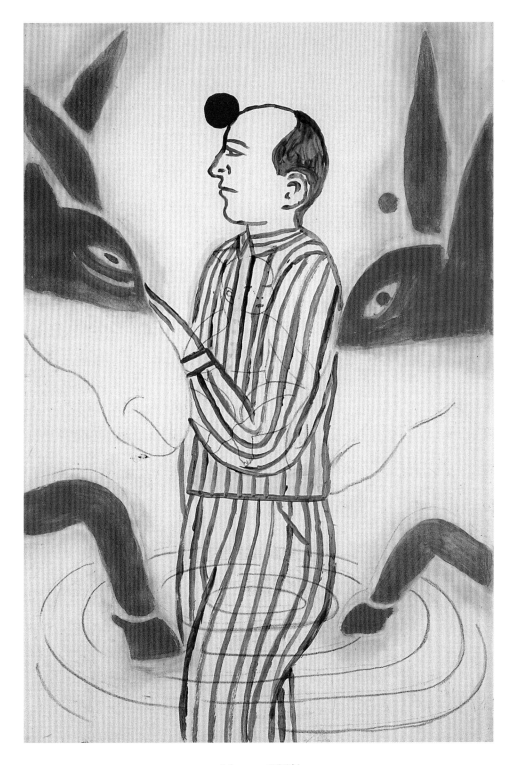

Mystery, 1997

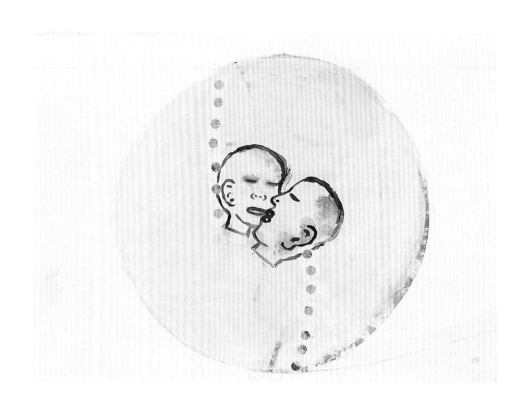

Little Pillow Mates, 1991

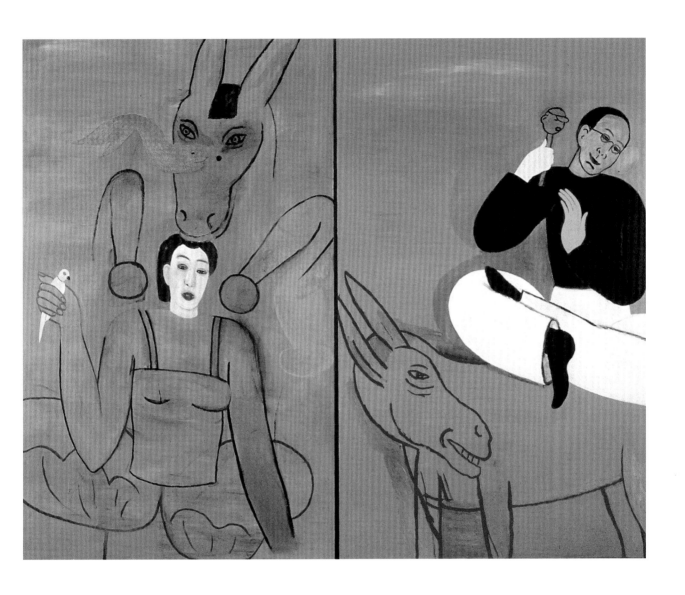

Shades, 1997

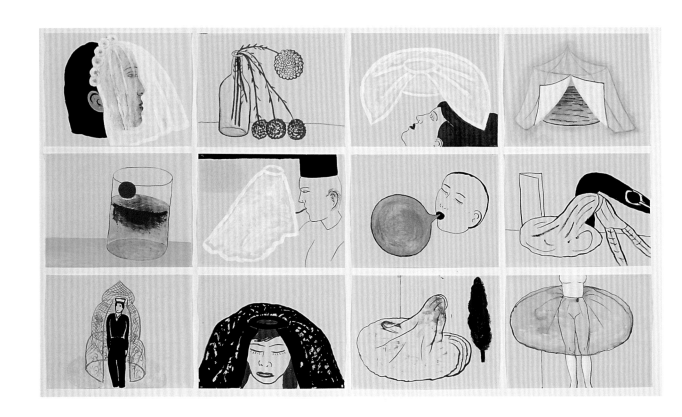

Lifting the Veil, 1994

Lifting the Veil

Just as she continually returns to the intimate rituals of coupling, Fay—a Gemini—works obsessively with images that manifest the dual nature of individuals. The pictures I refer to as couplets—rhyming pairs of figures or single figures divided—teeter along the edge of symmetry, their compositions shaped by their meaning. Doubled images of animals and humans recur throughout Fay's work, stacked or joined like paper cutouts.

The group of pink paper drawings collectively called *Lifting the Veil* (p. 52) that she made after a trip to Ireland in 1991 presents a more complex exploration of duality. It suggests both a sexual awakening—the physical aspect of coupling—and, in Jungian terms, a psychological integration of anima and animus, innocence and experience, instinct and reason.

The images are quickly brushed on sheets of pulpy blush-pink paper—an irresistibly sexy medium. The paper was left behind in a studio that Fay took over from her friend, Andy Keating, an artist well versed in the subliminal power of pink. Each of the dozen drawings in the group divides into two parts: black hair, white veil; vase and flowers; veil and head; tent and water, and so on. Enigmatic as the pictures are individually, as a group they make an immediate

impression. Jones recalls that she had the drawings hanging during a studio tour and, as a cluster of women looked at the work, one of them burst out, "It's about losing your virginity, isn't it?"—then blushed.

Fay says she did have a loss of innocence in mind when she made the drawings, but did not make them consciously or in a particular narrative format. While in Ireland she had come upon a confirmation party, an extended family celebrating a young girl's first communion, and with that in mind she made the initial image of a girl in a white veil. The rest of the drawings, she says, "happened more or less automatically." She assembled them in a single time-lapse composition afterwards.

Because equal importance is given to every part of the composition, it lacks the obvious focal point of traditional academic painting. The arrangement of the piece forces the eye to move continually, like the overall abstractions of Mark Tobey or Jackson Pollock. Yet, almost as a joke, the blank space dividing the individual sheets of paper creates a grid, the basis for academic composition. And that silvery circle, just right of the centerline, seems to mimic a focal point, even though our eyes pull away from it, out to the edges, rather than toward it. Fay seems to be using the "big bang" method of composing: she's made an expanding universe complete with a triangle of powerful black holes, gravitational fields that keep our eyes spinning in an elliptical orbit, from upper left to center right to mid-lower left.

The two most obscure images lie at the center of the piece: a male head attached by his mouth to a floating veil and a female head extruding a silvery bubble the same size as her head. We can think of the figures in these two images as mediums emitting a ghostly ectoplasm, materializing their psychic doubles in a way that suggests the activating of their female and male counterparts, anima and animus. It's interesting to note that the veil is shaped like the handkerchiefs in *Gifts*, while the silvery bubble recalls the man's bowling-ball hands.

More than simply a sexual awakening, the images in *Lifting the Veil* evoke an Edenic loss of innocence, an assimilation of aspects of human nature, and therefore the self, that were previously unfamiliar. As always, color is an inherent part of the symbology: the tender femininity of pink, the duality of black and white, the fertility of green. Red, when it appears, is always highly fraught: the flaccid red flowers look like cherries (those icons of virginity) as well as the fleshy flowers of the amaranth, which appear in another Jones painting and are known by the common name "love lies bleeding"—surely the flowers from which defloration got its name. The cherry in the cocktail glass, awash in red, renews that idea while also hinting at another female rite of passage: the first flow of menstrual blood.

There is no sense of real space in any of the individual drawings, and even less in the aggregate composition. The actions and images exist in a metaphorical, not a physical, world. Fay repeats the image of the circle, a traditional signifier of union and wholeness, throughout the composition, and the duality of all the individual images joins, finally, in the last drawing, at the lower right. In India, the lingam and yoni, venerated Hindu symbols of male and female sexuality, are worshiped in union, as a representation of fertility and the divine power of creation. In Jungian terms, that union suggests psychological integrity.

Gemini, 1998

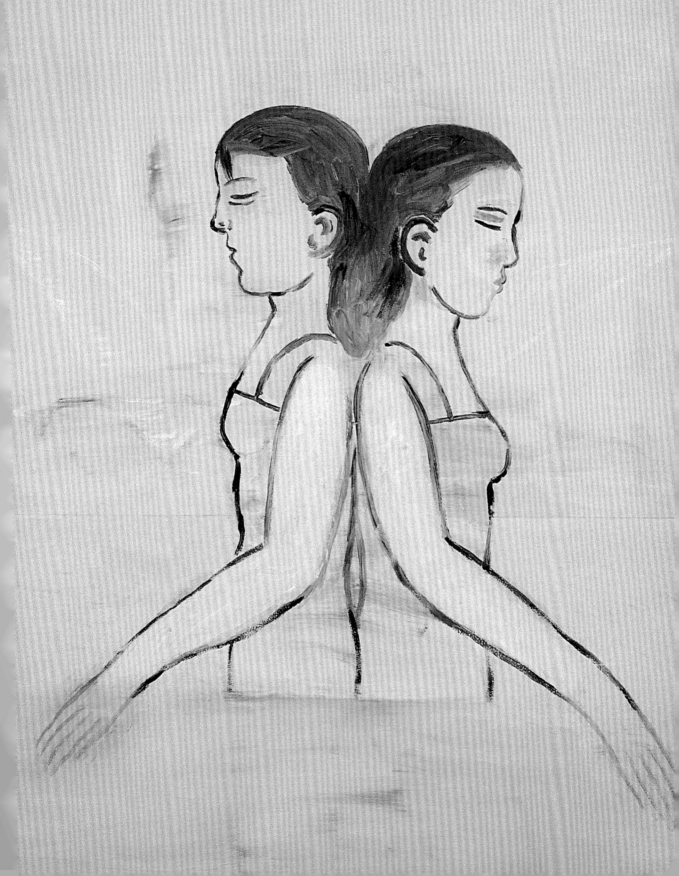

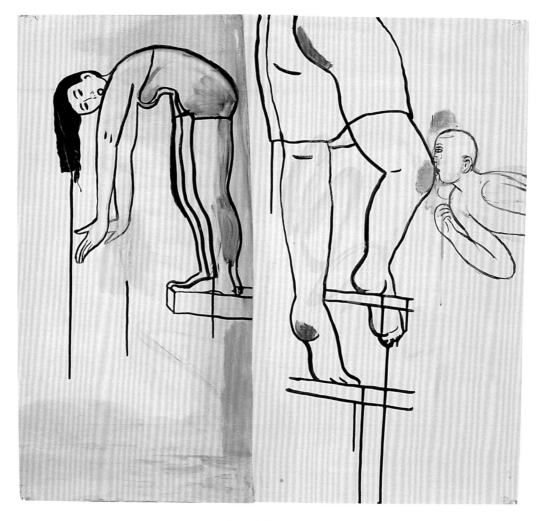

Acrophobia, 1995

Stack of Pallid Monkeys, 1998

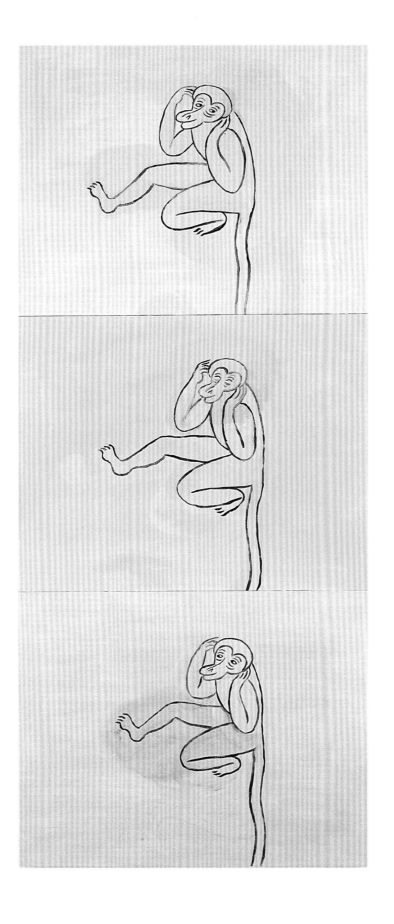

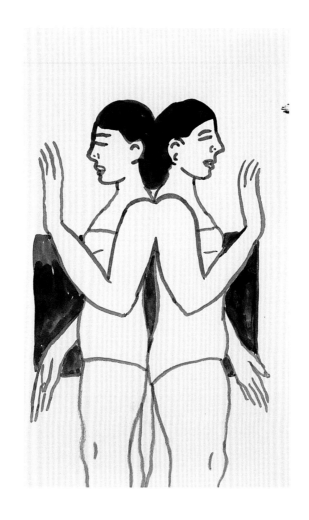

Notebook V #2, 1994

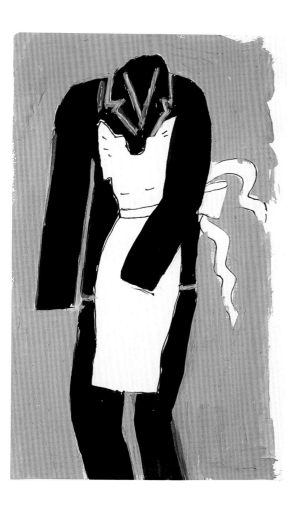

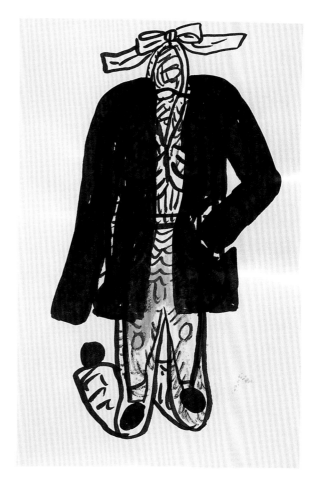

Notebook II #1, n.d.

Notebook IV #4, n.d.

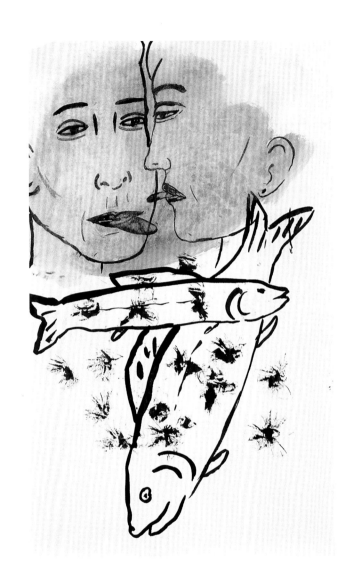

Notebook V #1, 1994

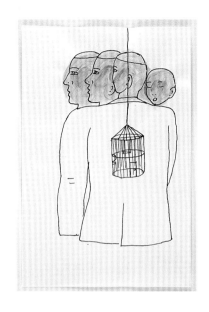

Notebook IV #1, n.d.

Notebook XI #1, n.d.

Notebook VIII #3, n.d.

Notebook III #3, n.d.

Mann on Mountain, Hunter on the Plain, 1985

Book Collages

Fay is so attuned to the two-ness of her life experiences that she decided to chronicle the strange bedfellows on her bookshelves. Here is a list of the paintings that resulted, along with the names of books that sacrificed their very pages for her art.

Mann on Mountain, Hunter on the Plain

Magic Mountain, Thomas Mann /

Fear and Loathing in Las Vegas, Hunter S. Thompson

Irish Myth

The Last Hurrah, Edwin O'Connor / *Irish Folk Stories and Fairy Tales*,

edited by William Butler Yeats

Alice Meets Betty and Alice vs. Betty

The Feminine Mystique, Betty Friedan / *Alice and Wonderland*, Lewis Carroll

Swann's Motel

Swann's Way, Marcel Proust / *Motel Chronicles*, Sam Shepard

Jane on the Road

Jane Eyre, Charlotte Brontë / *On the Road*, Jack Kerouac

Jane on the Road, 1985

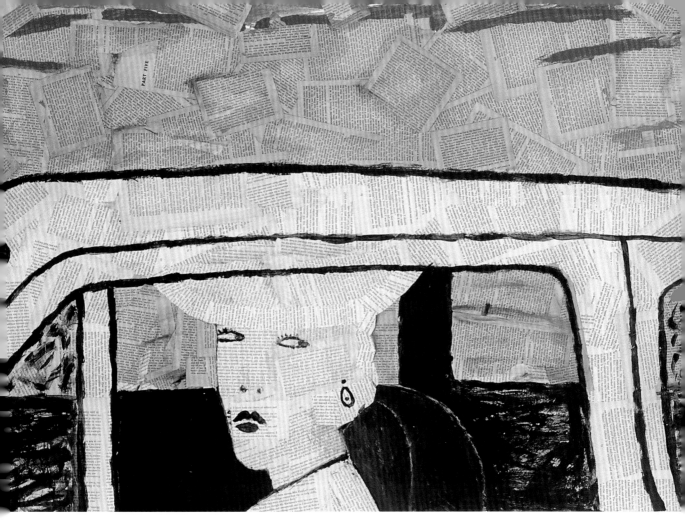

Pablo and Vincent (no longer exists)

Lust for Life, Irving Stone / *Life with Picasso*, Françoise Gilot

Hotel Massachusetts

Hotel New Hampshire, John Irving / *Parrish*, Mildred Savage

Bks.

Fahrenheit 451, Ray Bradbury / *Webster's New World Dictionary*

Fairytales 1945

The Book of Fairy Tales / *At the Back of the North Wind*, George MacDonald

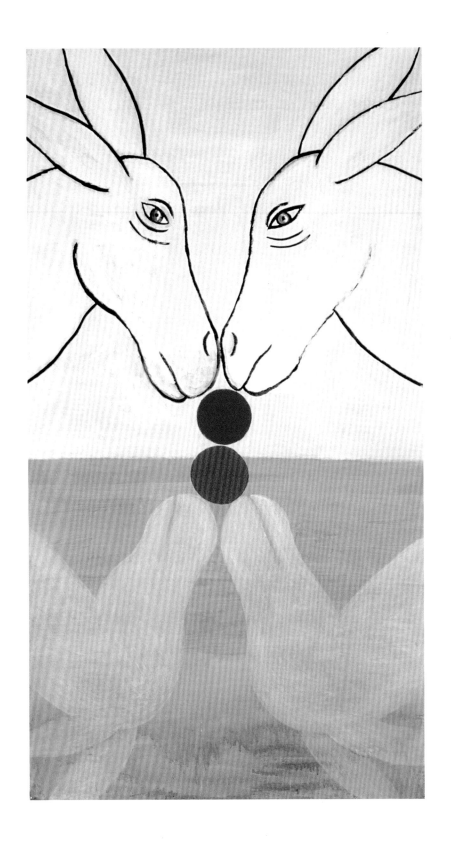

Narcissi, 1997

A Queen's Bath

Sometimes in a Fay Jones painting, a dog is just a dog. More often, though, when an animal appears, it acts as a messenger of some sort, playing a central role in the metaphoric substance of the piece. And no animal appears more often than the humble donkey. For a clue to the role that the ass plays in Fay's work, read this passage from *Man and Beast: A Visual History* by Jacques Boudet (1964), a book she bought for her children when they were growing up. Now it stays at her studio, an essential reference tool:

> The most famous donkey in all holy writ is the one which was carrying the false prophet Balaam on his way to curse the Hebrews before the king of Moab. An angel barred the way and the animal, a she-ass, refused to go on. When she was beaten cruelly she began to speak, blaming her master for his harshness and telling him to go back the way he came. Exegesis has seen this as a forecast of Christ's appearance to Saint Thomas, but the legend of the animal which is guided by its instincts to show greater wisdom than man is a favourite one in all folklore.

Beyond its instinctual wisdom in Christian exegesis—acting as a conscience, a purveyor of the moral truth to its human owners—the donkey is a traditional beast of burden and, as such, has been among the most abused of all animals, sometimes literally worked to death. Fay keeps that aspect of the beast firmly in mind, and sees a strong relationship between the donkey's domestic work and that of women. In Mexico, where the Joneses spend part of the year, donkeys are still commonly used as work animals and for transportation.

The most extraordinary of Fay's drawings, a big triptych titled *Poppaea's Herd* (pp. 72–73) was inspired by another passage in *Man and Beast*. In ancient Rome, women used ass's milk to improve their complexions. The emperor Nero's wife, Poppaea, with an extravagance typical of her degenerate era, insisted on more than just a milky rinse for her face. Whenever she traveled, she took a herd of four hundred she-asses with her—shod in gold and embellished with jewels—so that she would have a steady supply of warm milk for her twice-daily bath.

Thinking about Poppaea's ritual prompted Fay to a ritual of her own. For ten days she would draw forty she-asses each day, until she could see before her just how many animals it took to service the empress's beauty. The implications of such royal narcissism go without saying: people starving while the queen bathed in milk; human slaves abused while the queen's herd glittered with jewels. The absurdity is so specific, yet at the same time such a universal symbol of tyranny, that it stands alongside Marie Antoinette's reputed remark: "Let them eat cake." That women have historically been both beasts of burden and tyrants makes a perfect dual meditation for Fay's visual mantra on the Roman empress.

Fay gave names to every one of her she-asses. She says that writing out their names reminded her of being in Delphi and seeing the names of former slaves carved into stones, a testimony to their freedom.

It's typical of Fay that the methodology of her project was not sacrosanct: "I decided I'd do forty a day," she said. "But I didn't do forty a day. It was like any other assignment—sometimes you get behind in your homework."

Angela, Abigail, Astrid, Amy, Anstice, Anita, Agatha, Agnes, Allison, Alice, Adele, Anna, Adina, Ali, Amanda, Ava, Alicia, Ann, Anjelica, Alexandra, Amalia, Arabella, Aurora, Annaliese, Alix, Adrienne, Agrippina, Anouk, Assuncion, Alberta, Aphrodite, Amethyst, Alana, Alma, Andromeda, Antoinette, Astarte, Antonia, Astraea, Augusta, Bella, Barbara, Bessie, Bettina, Beth, Billie, Bridget, Bonnie, Benjamina, Bobbie, Beryl, Bambi, Beverly, Bunny, Brigitte, Betty, BabyCakes, Beulah, Babs, Berenice, Bernadette, Bertha, Birdi, Blossom, Brandy, Brunnhilde, Carolyn, Cora, Christina, Clytemnestra, Chloe, Cherry, Cecilia, Claudia, Coco, Candace, Cassiopeia, Carmen, Candida, Caitlin, Carol, Catherine, Charlotte, Chastity, Cinderella, Corinne, Colleen, Constance, Cynthia, Cookie, Cleopatra, Charlene, Circe, Cherie, Darlene, Denise, Dido, Dorothy, Danielle, Daisy, Deborah, Diana, Dolly, Dixie, Dagmar, Della, Delilah, Dotty, Desdemona, Donna, Evelyn, Eva, Esther, Eloise, Electra, Emmeline, Edna, Ellen, Eleanor, Effie, Emerald, Elizabeth, Flora, Faith, Fanny, Faigola, Florence, Frances, Francesca, Fredricka, Georgina, Gillian, Gladys, Grendel, Galatea, Geraldine, Gemma, Gussie, Gertrude, Georgia, Gwyneth, Glynnis, Gabrielle, Gina, Giovanna, Grace, Gail, Gigi, Hermione, Hope, Hester, Hattie, Hepzibah, Holly, Honora, Henrietta, Hannah, Hetty, Hortense, Harriett, Isolde, India, Inez, Isabel, Isadora, Iris, Iodine, Imelda, Ileana, Ida, Iphigenia, Immaculata, Indira, Ione, Irene, Ivanna, Ilka, Inga, Io, Ingrid, Jacqueline, Janet, Jill, Jonelle, Josephine, Jessie, Julie, Jolene, Justine, Judy, Junco, Joyce, Juliana, Katharine, Kristin, Kitty, Kelly, Kate, Kim, Karma, Leah, Lily, Laura, Letitia, Lauren, Lola, Liz, Lorenza, Lara, Lavinia, Livia, Lydia, Lucretia, Loretta, Lana, Linda, Lamar, Lucy, Liane, Leatrice, Lisa, Lucinda, Mary, Molly, Martha, Mariah, Maureen, Marcia, Mathilde, Minerva, Margaret, Merrily, Maggie, Marisol, Madeline, Myrna, Musetta, Michaela, Minnie, Melody, Mina, Marianne, Maxine, Mona, Marpessa, Mia, Mara, Monique, Mimi, Melanie,

Pages 72–73: *Poppaea's Herd*, 1997

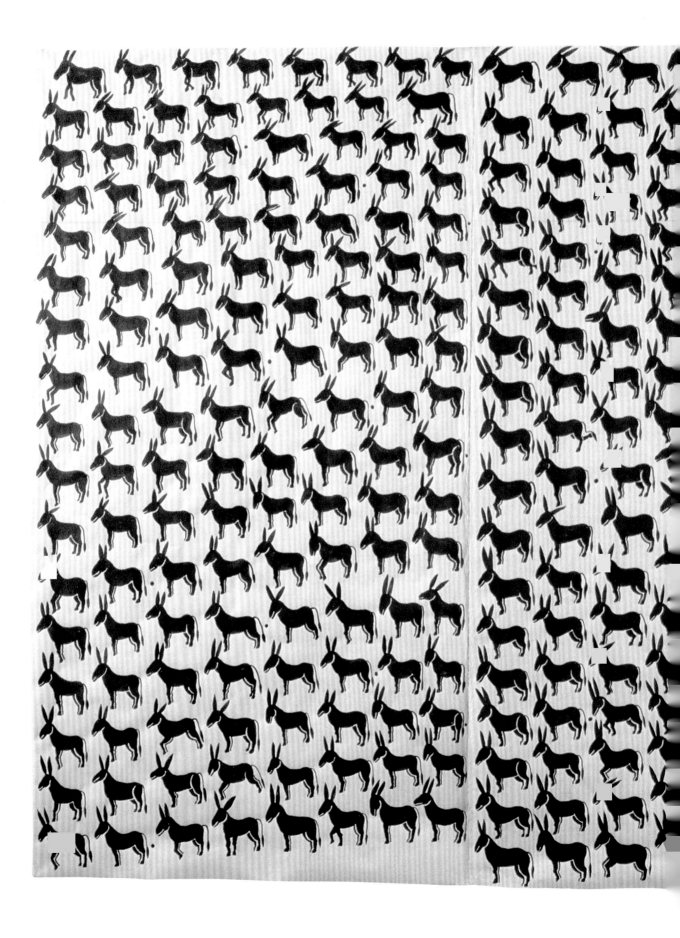

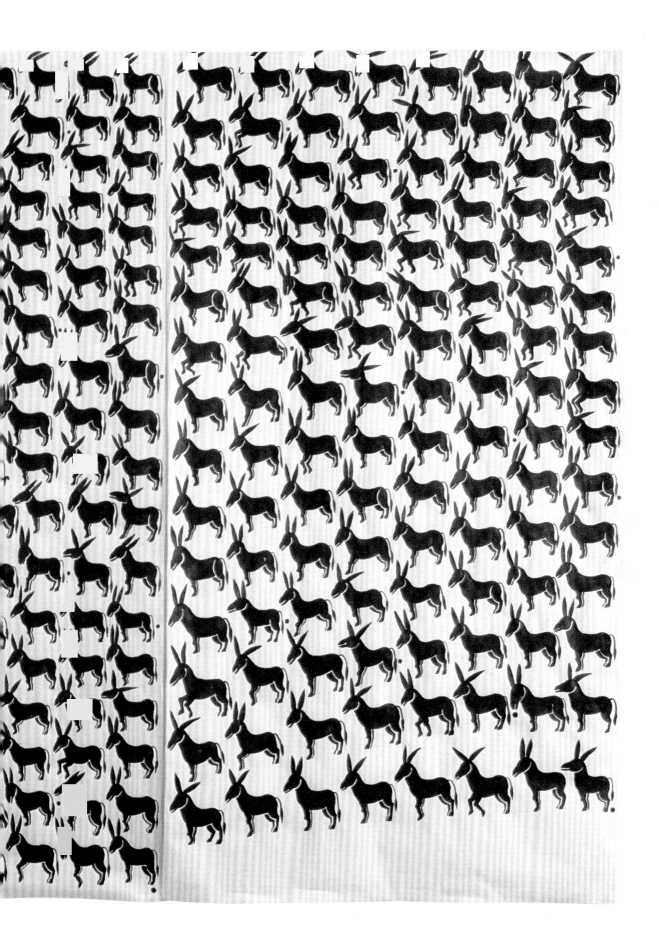

Nelly, Nancy, Norah, Nina, Natalie, Nanny, Nettie, Nicole, Norma, Noelle, Narcissa, Nadia, Nannette, Neva, Nola, Nichola, Neola, Nollie, Noreen, Nefertiti, Olive, Olina, Ola, Odessa, Octavia, Olga, Olympia, Opal, Omphale, Ophelia, Orlando, Patricia, Portia, Petunia, Penelope, Penny, Pamela, Patsy, Priscilla, Pallas, Paloma, Pandora, Pearl, Petra, Paula, Peggy, Perdida, Persephone, Philippa, Phoebe, Philomena, Phyllis, Posie, Princess, Polly, Queenie, Quinn, Rose, Ruby, Rima, Ruth, Raquel, Raven, Rhonda, Rebecca, Rusty, Rosemary, Rachel, Rain, Ramona, Regina, Reed, Remedios, Robin, Rosalie, Rosamund, Sarah, Samantha, Sally, Stephanie, Sophia, Sacajawea, Sissy, Sapphire, Stella, Star, Shelagh, Sybil, Sandra, Sanjuana, Sojourn, Selene, Susan, Serena, Sorrow, Suzanne, Shirley, Shoshana, Siobhan, Sherry, Shelley, Shalimar, Signe, Shannon, Sylvia, Smadar, Salome, Sophronia, Sugar, Sunny, Theodora, Teresa, Tomasina, Trisha, Tabitha, Tamsin, Thalin, Twiggy, Trudy, Tuesday, Terry, Thea, Tara, Thumbelina, Tess, Tammy, Tilly, Uma, Ursula, Urania, Valerie, Vanessa, Virginia, Varda, Veronica, Vera, Vivian, Vesta, Victoria, Venus, Vanna, Wilhemina, Wallis, Wanda, Xanthippe, Yvonne, Yadviga, Zenobia, Zia, Zarina

Nose, 1996

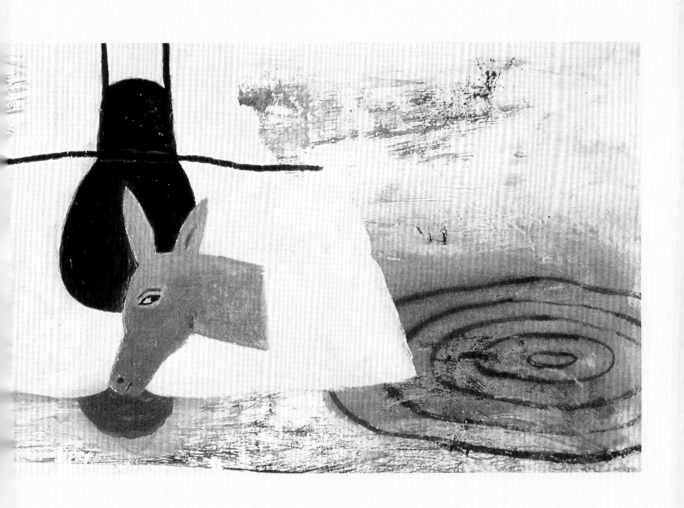

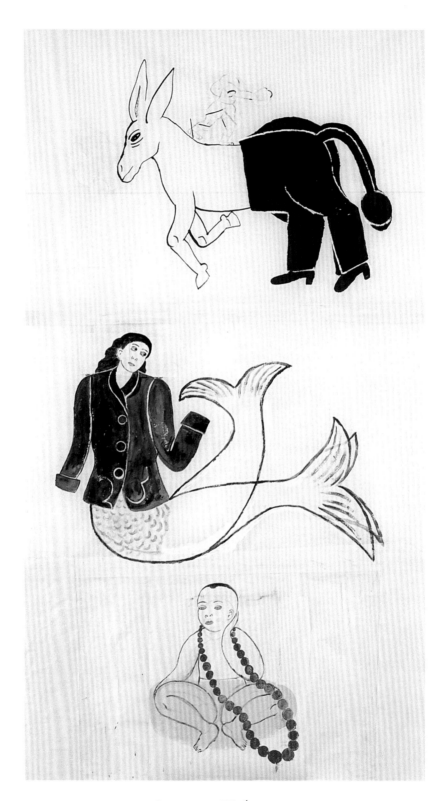

Incongruous Weight, 1998

Queen's Bath, 1997

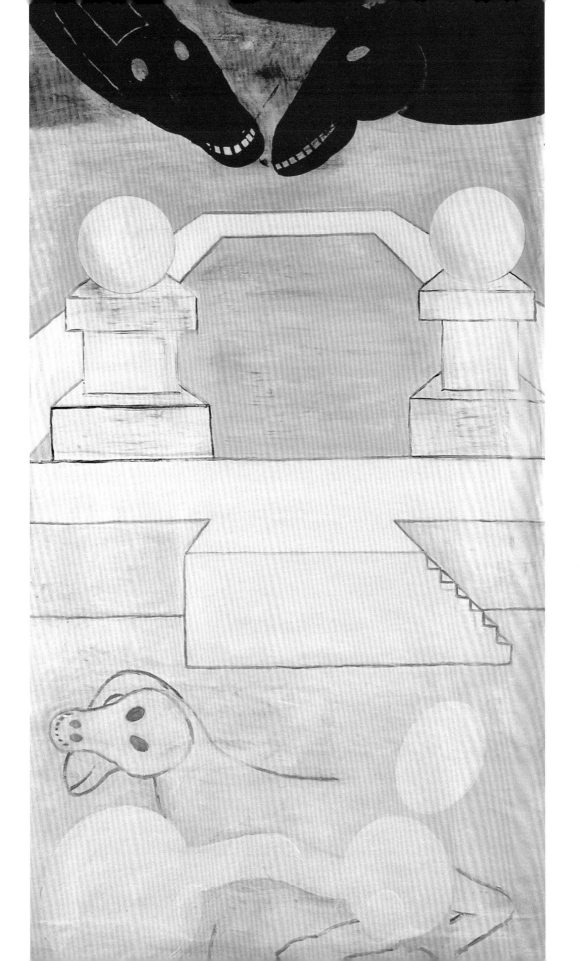

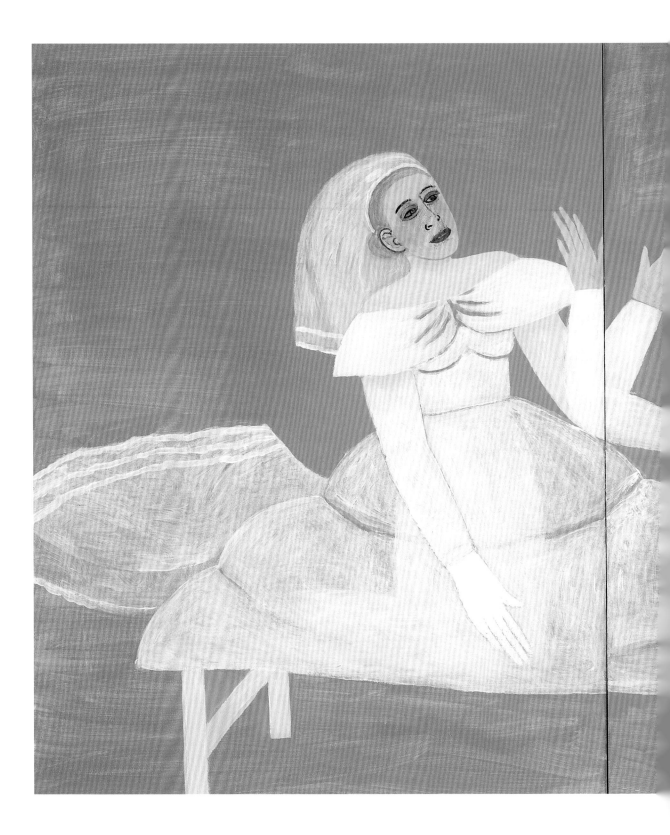

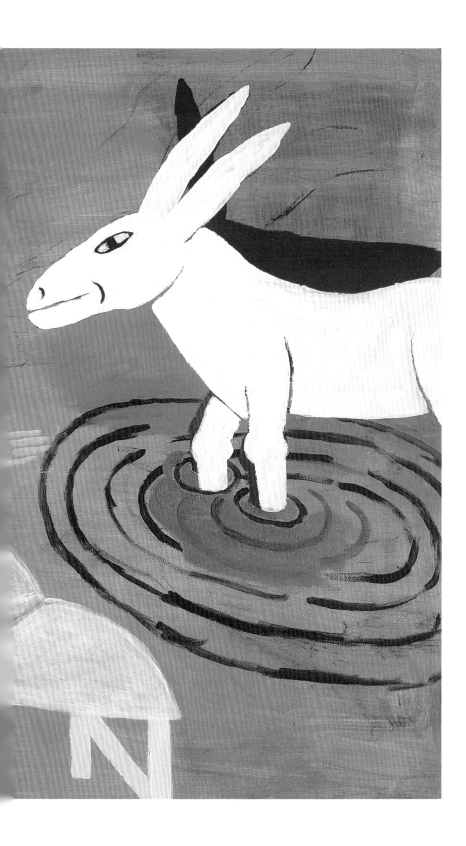

Stranded Bride, 1999

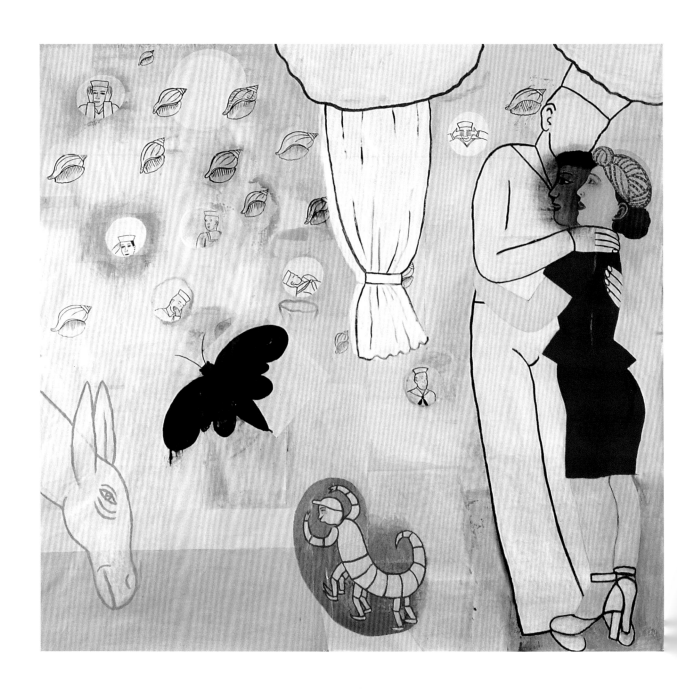

Embracing the Spectre, 1997

The notion of murder often brings to mind the notion of sea and sailors.
Sea and sailors do not, at first, appear as a definite image—
it is rather that "murder" starts up a feeling of waves.

—Jean Genet, *Querelle*

Sailors/Sleepers

The sailors who turn up in Fay Jones's paintings have a dangerous undertow. Often we find them sleeping, innocent as cats; but their allure can be a siren song. As a girl, during World War II and afterwards, Fay remembers being warned about sailors prowling the Atlantic beaches and streets of the New England port cities where she grew up. Exotic creatures in their form-fitting bellbottoms, they were cloaked in all the mysteries of long sea journeys, far-off lands, strange languages, potential violence, and male sexuality.

Decades later, sailors began to show up unbidden in Fay's paintings. She never questioned their presence or tried to pin them to any meaning, although she does admit trying to evict them when she felt they'd overstayed their welcome. Symbolically, they are intriguing both as voyagers and sleepers.

Artists have always depicted tales from the Bible and classical mythology, familiar stories of gods and heroes whose interactions encapsulate basic psychological truths. Fay does the same thing, but with a cast of gods and goddesses, heroines and demons, costumed to fit the contemporary world. She doesn't go about it consciously, like a director setting a Shakespearean play in modern times. But somehow, in her work, she manages to steal into the theatre of our collective

unconscious, where such comedies and tragedies are always being played out. As in Alice's Wonderland, the usual laws of logic and physics don't apply.

That's why Fay deliberately avoids setting her compositions in "real" space, subject to the laws of proportion and perspective. Rather than try to make a scene appear "realistic"—which is, after all, a pictorial illusion—she places her images deliberately at odds with the rules of the natural world. A black moth can be the same size as a donkey's head. Background and foreground often are un-differentiated. She isn't doing this, as some contemporary artists do, to make the work appear naive. Jones uses space in a sophisticated way, reminiscent of Hindu miniaturists who eschewed normal perspective for a good reason: to indicate that the action is taking place in the arena of the gods, where time and spatial bound-aries dissolve.

Sailors are headliners in our theatre of inner experience. Think of Odysseus and his harrowing, ten-year journey home, or the old Anglo-Saxon poem "The Seafarer," or Coleridge's "Ancient Mariner"—tales Joseph Campbell classified as "the hero's journey." Fay's sailors resonate to a certain degree with those images, but because they are often shown asleep, they assume a darker aura. They are more primal. These creatures may have the potential to be heroes, but that would require conscious action. Fay's sailors navigate the perilous sea of the unconscious, but not with foresight, intelligence, and godly intervention, as Odysseus did, but more like his crew, who responded with blind instinct to every situation and perished as a result.

The fact that her sailors are common, rather than heroic, relates to Fay's affection for vulgarity. She prefers to make art with an unelevated vocabulary. She has no reverence for her materials or the artistic canon, although she does respond to Renaissance beauty (her first glimpse, in Italy, of a Botticelli and Uccello, she said, made "the hair on the back of my neck go straight up"). Just as Dante chose to write his *Divine Comedy* in the language of the people, rather than

Latin—at the time the only acceptable tongue for literature—Fay has rejected the rules of "serious" painting for a casual style where all that matters is the picture itself.

Fay's sailors, who sleep more or less fitfully in all of us, are brain-stem driven, pleasure-craving creatures, given to drunkenness, sexual predation, and carnivorous violence. They are like the Dionysian revelers at the end of Euripides' play *The Bacchae,* sleeping off a murderous orgy, which, when they finally awaken, will seem unthinkable.

Lone Tar, 1991

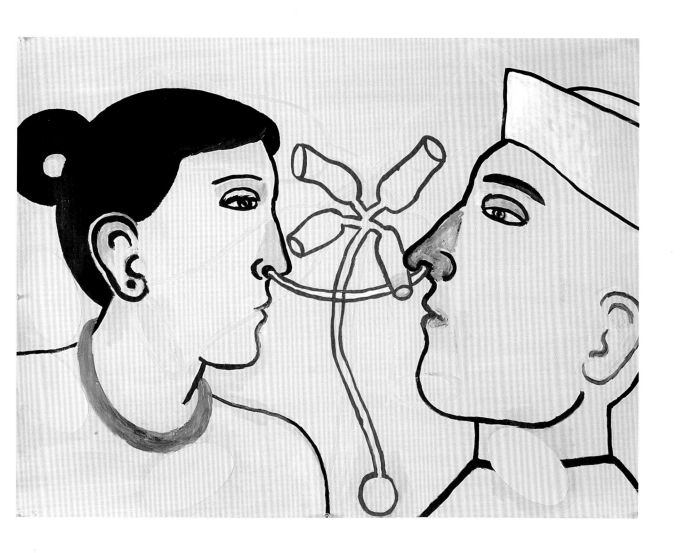

Smell, 1996

Strange Pursuit, n.d.

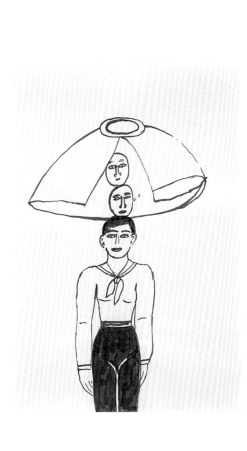

Notebook IV #5, n.d.

Compliance, 1991

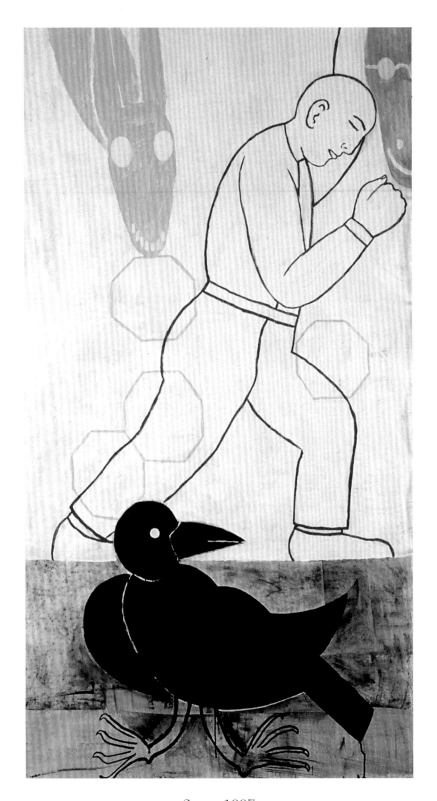

Sorrow, 1997

Beating Odds, 1998

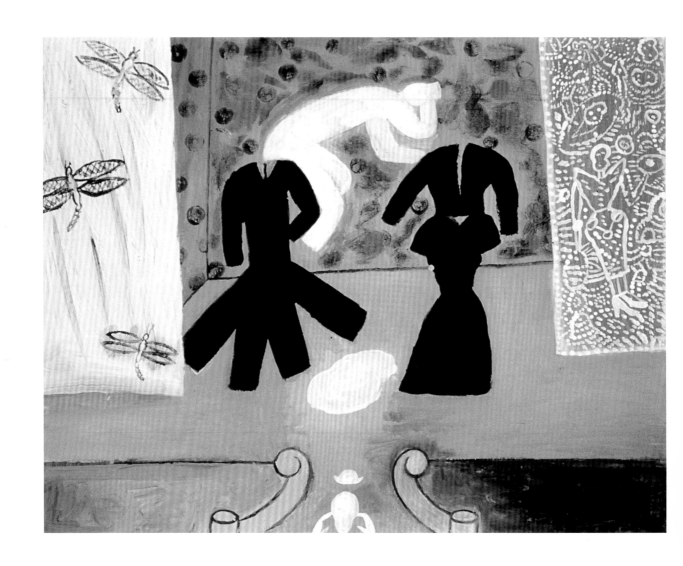

Wardrobe Interior, 1991

Thrice Told Tales

More than any other writer, Marcel Proust understood the role that memory plays in the appreciation of art. Secluded in his cork-lined bedroom, without the sensual overload of recorded music or television—the second-hand experiences that are the drugs of the electronic age—Proust recollected his aesthetic pleasures in solitude and defined them for us in his writing. A piece of music heard for the first time, he realized, flows through the mind of a listener like water. It is only with the second hearing that it germinates there, when memory coalesces with the present and future. Then we experience not only the immediate pleasure of the work's harmonies and rhythms, but the titillation of anticipating what is to come.

The repetition of sounds and rhythms, harmonic combinations, and visual imagery, captivates us with its primal power. Fay's fascination with doubled images—couplets—and her work with multiplied images such as *Poppaea's Herd*, leads to the more complex, more musical formal arrangement of *Thrice Told Tales* (pp. 95–97).

The series began formlessly. Fay indulged in some pads of fine Italian watercolor paper—beautiful objects in themselves with their sealed edges and

exotic covers—and decided to give herself an assignment: she would use one of the pads to make twelve little paintings. At some point she decided to redo one of them, which led her to the idea of replicating them all, making three versions of each image. "Essentially I was copying myself," she said. "And some I could improve on. The problem was to repeat things I thought were perfectly fine." The really interesting part, Fay says, was deciding how to assemble the images—a structure that went through several mutations until, as it now stands, "The whole is greater than the sum of its parts."

In a way, the series recalls the Kurosawa film *Rashomon,* in which a single event is recounted by several witnesses and each one remembers it differently. In *Thrice Told Tales* each repetition of the image, though the composition is the same, suggests a unique interpretation. Fay's language of color—and the way color shapes meaning—becomes sharply apparent, as each image progresses from its first to its final "telling."

In *Nightmare,* the objects are defined by color in Part I. The jet-fueled woman's robe at upper right is pink and magenta, the wall grey: the objects appear solid, except for the male figure intruding into the top right corner of the picture space, just an outline. In Part II, the objects have become transparent; a background appliqué of blossoming pomegranate branches supersedes them in Matisse-like arabesques of vivacious shape and color. The man, however, his outline now filled in, has become substantial. It's as if the first recollection of the dream were from the perspective of the robe, the second from that of the man. In Part III, the vibrant appliqué of pomegranate flowers and fruit has been replaced with a colorless painted version. In fact, all color, all emotion, has seeped out of the *Nightmare,* which now seems like a distant memory. Only the robe is vivid and golden, like a hand-tinted embellishment to an old black and white photograph.

The title *Thrice Told Tales* and the series of individual frames—a familiar comic book format—may mislead some viewers into thinking of the piece literally as a narrative. Yet, if "read" from left to right, line by line, the movement and effect of the piece are more like a poetic form, something like Wallace Stevens's voluptuously visual "Sea Surface Full of Clouds," a tour de force structure devised by the poet. The basic imagery of the poem, relayed in six three-line stanzas with an elaborate rhyme scheme, is repeated, with variations, five times. It resembles a musical structure, like a fugue or rondo. In Jones's *Thrice Told Tales*, each of the twelve tripled basic images forms a varied yet repetitive structure, like a poetic stanza, satisfying in itself, yet ever developing in context.

Seen as a whole, the composition is a riot of activity. There is no focal point for the eye to rest on. As in the first hearing of a piece of music, the formal pattern of the work is not immediately apparent; we experience a river of color and images, pleasing but chaotic. As literate people, our immediate impulse is to look for narrative flow, to read the piece like a comic book or frames of an animation—but no story line emerges. Instead, we begin to discover repetitions and to register the thrill of familiarity. First rhythm begins to pulse through the piece, and then we discern a melodic line with harmonies and variations.

In all the twelve repeating images, the urgency dissipates in retelling. Some of the color dissolves; a little of the vivacity fades each time around. The images turn ghostly and skeletal—just shadows and vacant forms, like tarnished memories. And, in an inspired use of materials, the images appear to be turning into something else. The collaged pages of text and musical notation beneath the paint seem to suck the life out of the visual images, to digest them, and transform them into another language.

The progression conveys a profound view of the way life experiences are transformed through contemplation into meaning. It reflects the way art is born

from an image, or an idea, and then—through some inexplicable impulse—metamorphoses into the language of its creative media, whether movement, music, words, or paint.

Like a poem or a piece of music, *Thrice Told Tales* incorporates the dimension of time—a feat most painting and sculpture can't achieve. It also suggests, in a very Proustian way, the action of memory: how the fullness and intensity of experiences transform in recollection, as they are joined by other experiences. The immediacy of beauty, terror, loss, desire, all evaporate and become part of a greater context, fuller meaning, a kind of transcendence.

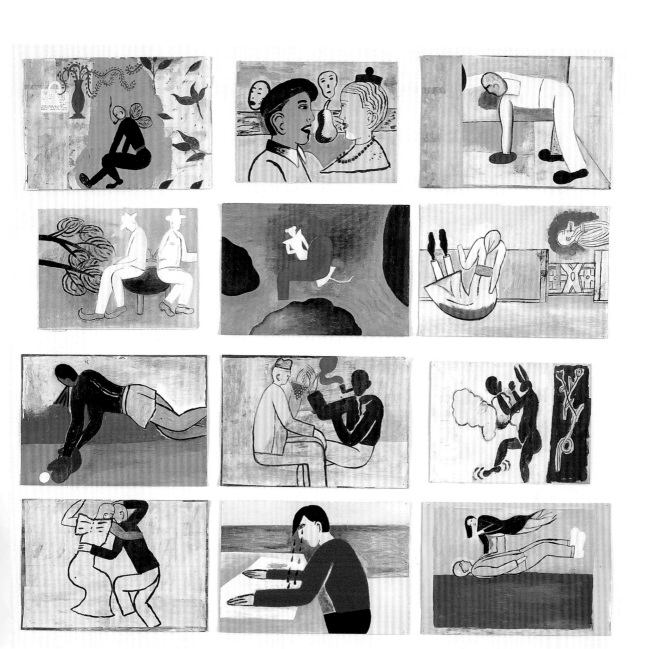

Thrice Told Tales, 1993
Part 1 of 3

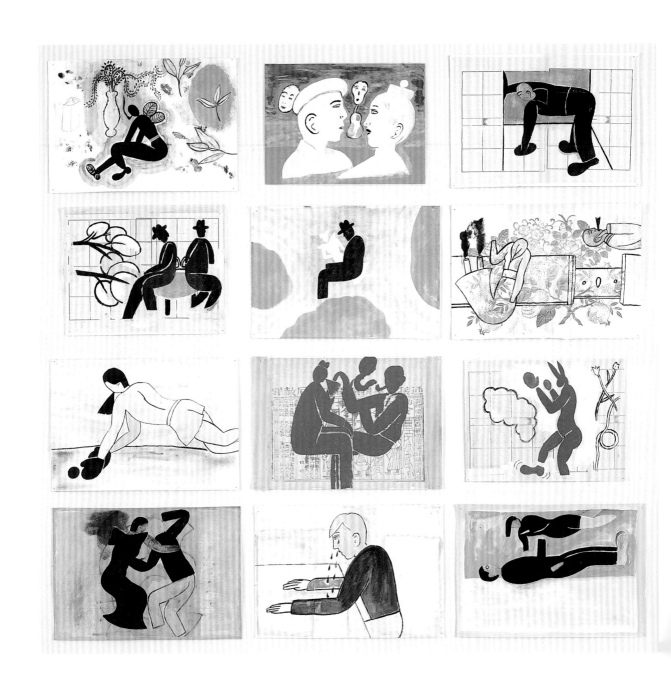

Thrice Told Tales, 1993
Part 2 of 3

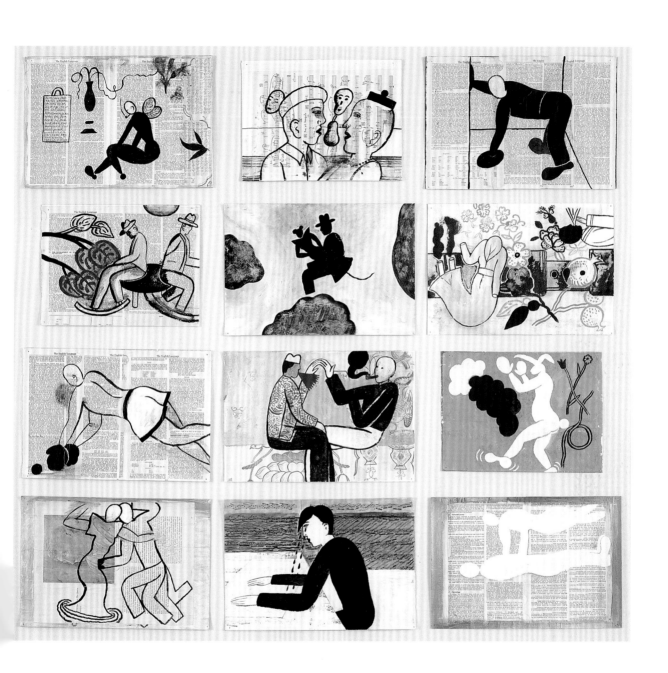

Thrice Told Tales, 1993
Part 3 of 3

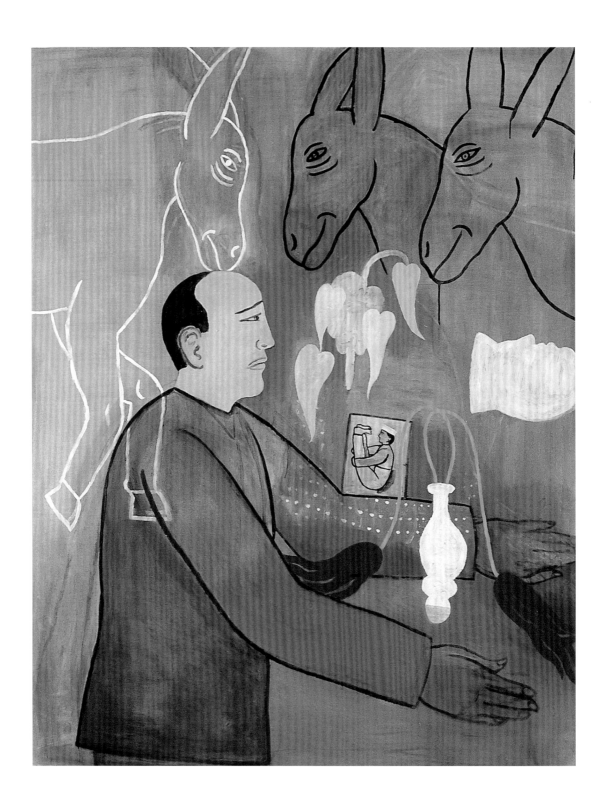

Love Lies Bleeding (Amaranth), 1997

Setups

For a while in the mid-1990s, Fay Jones painted movie illustrations for the *New Yorker,* those small reproductions that dot the calendar section or accompany a review. She liked the sudden deadlines and the challenge of applying her skills in a different context, but saw the work as totally separate from her painting. "You're using a different part of your brain," she says. Nevertheless, one of her assignments, an illustration for the Bernardo Bertolucci film *Stealing Beauty,* ended up haunting her.

Fay has long been an admirer of the Italian director's work, and when a packet of promotional materials on *Stealing Beauty* arrived from the *New Yorker,* she gravitated to one image in particular. "There was a photo of Bertolucci with Queen Anne's lace over his ear, and it was a beautiful photograph," she recalls, "just a really beautiful profile of a man who's made extraordinary movies." So after she whipped up an illustration of the movie's young star for the magazine —a forty-eight-hour deadline was the norm—she kept Bertolucci's picture at the studio, where he turned up as a figure in the painting *Love Lies Bleeding (Amaranth)* (p. 98). He also appeared in another large triptych called *Blue Moons* and in an etching, *The Conductor* (p. 104).

"In all cases he has some kind of director/conductor aspect," Fay says. "In *Love Lies Bleeding,* he looks generous, with his expansive gesture. The other figures are like a chorus, a Greek chorus, and the amaranthus [commonly called "love lies bleeding"] is from a friend of mine who used to bring me bunches of that. It's such a powerful plant. It looks like carnivorous chenille!" The figure of the handsome Italian film director in her work has little to do with who the man really is. He's playing a role. "I just absorbed him into something I needed," Fay says, "this specific figure who is either a conductor or a director. The action doesn't take place inside the painting; it's somewhere else."

Relating Fay's imagery to motion pictures should be simple, because the elements of motion, time, and meaningful gesture are so much a part of her work. But once again, we run up against the issue of narrative. Even when the paintings appear to have a narrative format, as in the small sumi and acrylic collage called *Full Length Feature* (pp. 112–113), we are being deceived. What at first appears to be a cinemagraphic progression of action—a sequence like the frames in a film clip—is actually what Fay calls a setup.

She means that the simulation of time and space is deliberately warped; things are incongruous. The action in *Full Length Feature* is probably closer to the way action takes place on a film set—out of sequence, with no pretense of real time, and all the false apparatus of the scenes exposed—than in the completed movie. It is typical of Fay's work that it makes us aware of the tricks and sleight of hand, the inner machinery of events and human relationships, rather than what's immediately apparent.

Sometimes she uses a setup for imagery that is more personal, as in *Dire Predictions* (pp. 106–107), which Fay calls her millennial painting. It's made up of metaphoric ingredients from her own life. "The cactus is from Mexico," she says, where she and Bob are building a house. "The sailor [swinging like a monkey from a branch] is finally cut loose somehow—you know, I'm always trying to

get rid of him. . . . There's the eruption and the plague [grasshoppers], the plague [rats], the child, the child, and the observer—he's the finger shaker, the guy who gives the warning. And then the big skirt, like a loose hive, but also like a mountain in a toy train set." That skirt envelops and erupts. It recalls the vast skirt of the peasant woman in the opening of Günther Grass's novel *The Tin Drum*, under which a fugitive hides and engenders a story.

Big skirts dominate several of Fay's recent paintings, acting almost as architectural elements in *Handmaids* (p. 111)—Fay's takeoff on the famous Velázquez painting *Las Meninas*. She thinks of them not as fashion statements, but in very feminine terms, as vacant but fertile spaces, uterine in their implications. Having grown up in the 1950s—an era of big skirts—Fay is intrigued with the idea of bigger as better. "What you were doing was creating sort of an interesting void," she says, "the space underneath the skirt—just the way it was in the Velázquez painting. Somebody told me that it was a sign of wealth. The bigger they were, the higher up the wearer."

The mountainous landscape of the skirt in *Dire Predictions* (think of the Sierra Madre range in northern Mexico) contains people, a railroad track, a volcano. It is the earth. It swaddles Fay's characteristic monkey figure and umbrellas a plague of rats lurking beneath it. But most surprisingly, it holds a vase of flowers with an eerie infestation. The body of that vase—another pregnant, female form—bristles with 365 tiny heads, which represent, Fay says, the days in a year and the hordes of immigrants trying, and at times fatally failing, to cross the borders of the United States. Tiny figures swarm up and over the flower stems like aphids.

"Like the Chinese people coming in those containers," she says, referring to a fin de siècle spate of refugees illegally entering the Port of Seattle in cargo shipments (in one container, three men died during the two-week confinement). "Which is so scary. Imagine that kind of desperation. . . . It's people coming

across the border from anywhere, and certainly from Mexico—they think it's worth all that." Fay's personal symbology adds an interesting dimension to the work, but the forms, all crowded together at the front of the picture space, divulge their own apocalyptic messages.

If feminine fecundity is an inherent part of Fay's imagery, it's because, for her, life and art are inextricable. "The reality of our having four kids is an important component of my work," she says. "If I'd had no obligations in life, I could have just drifted." It's been a driving factor, she says, "to have absolutely necessary things to do for other people." She's more disciplined in her work as a result, and it gives her something in return. Even now, she insists that when she spends time with her children's children, it isn't just to be a good grandmother. "You listen to what they say, watch them grow and change, and it's interesting. You are part of their lives." Besides, as she points out, most artists don't have the luxury of working at their art full time anyway and maybe it's better not to. Before art, there has to be experience. Form wants content.

In her painting, Fay shows concern for the ordinary components of life rather than the ideal ones, the substance beneath the surface. She is aware of the multiplicity of existence and never loses her sense of awe at the way terror and pleasure coexist. Fay's favorite poem, which she carries around in her head, is W. H. Auden's "Musée des Beaux Arts," prompted by Brueghel's painting *Landscape with the Fall of Icarus*. The poem deepened her appreciation of the painting, made her look at it in a fresh way. With Auden's words inhabiting her head, Fay unwittingly paid tribute to them in the painting *Dancing on the White House Lawn* (p. 110). As she was jotting down the title in shorthand: "Dancing on the W. H. Lawn" she immediately thought: W. H. Auden.

"I wouldn't set out to make a painting that was about that. But after I painted it I realized how close the title was to Auden, and that actually it was appropriate. That was the odd thing. The painting is about the fact that ordinary

things are happening at the same time as cataclysmic ones, and that life goes on. Which is really about everything, isn't it?"

Musée des Beaux Arts

About suffering they were never wrong,
The Old Masters: how well they understood
Its human position; how it takes place
While someone else is eating or opening a window or just walking
 dully along;
How, when the aged are reverently, passionately waiting
For the miraculous birth, there always must be
Children who did not specially want it to happen, skating
On a pond at the edge of the wood:
They never forgot
That even the dreadful martyrdom must run its course
Anyhow in a corner, some untidy spot
Where the dogs go on with their doggy life and the torturer's horse
Scratches its innocent behind on a tree.

In Brueghel's *Icarus,* for instance: how everything turns away
Quite leisurely from the disaster; the ploughman may
Have heard the splash, the forsaken cry,
But for him it was not an important failure; the sun shone
As it had to on the white legs disappearing into the green
Water; and the expensive delicate ship that must have seen
Something amazing, a boy falling out of the sky,
Had somewhere to get to and sailed calmly on.
—W. H. Auden

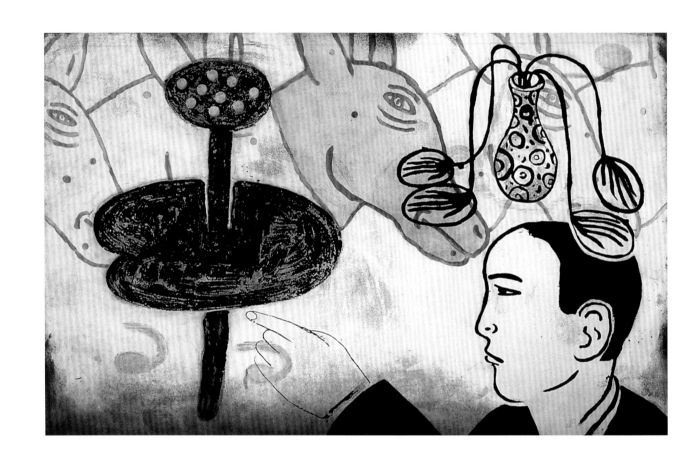

The Conductor, 1997

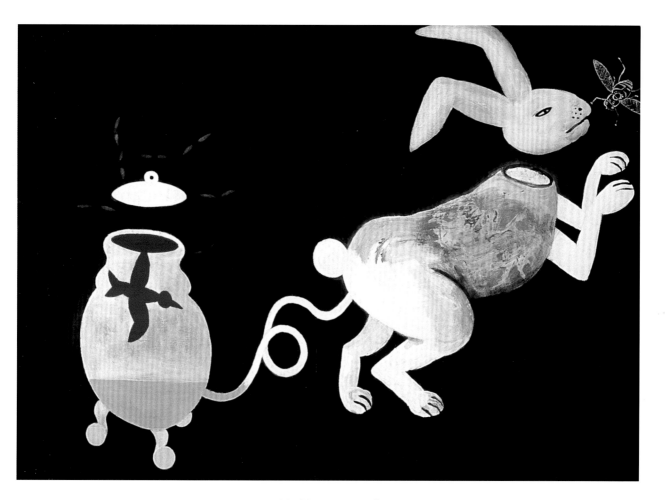

TwoTureens, 1996

Pages 106–107: *Dire Predictions,* 1999

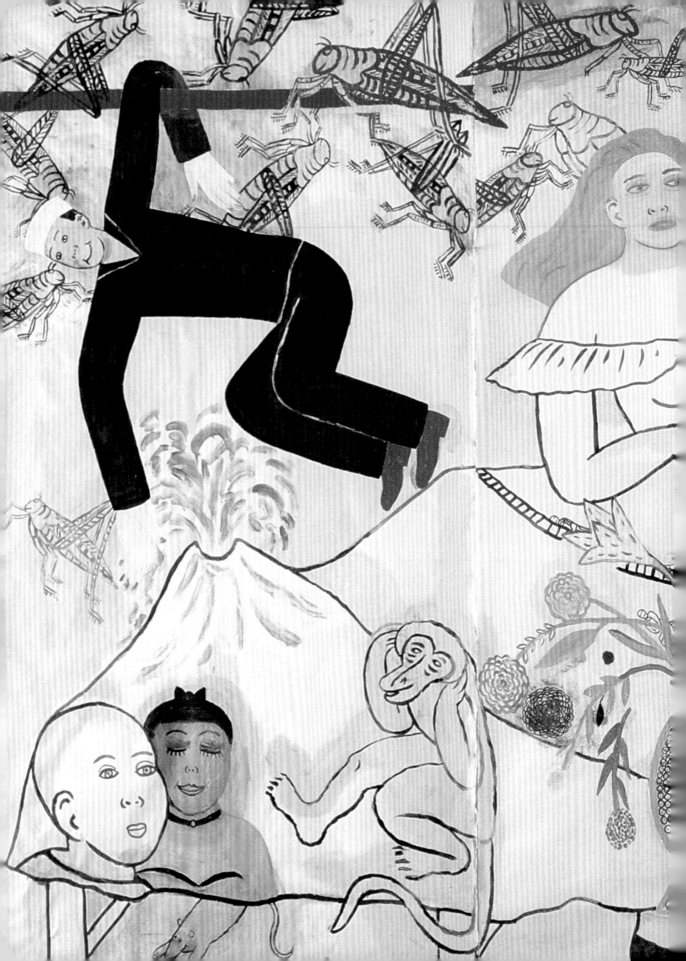

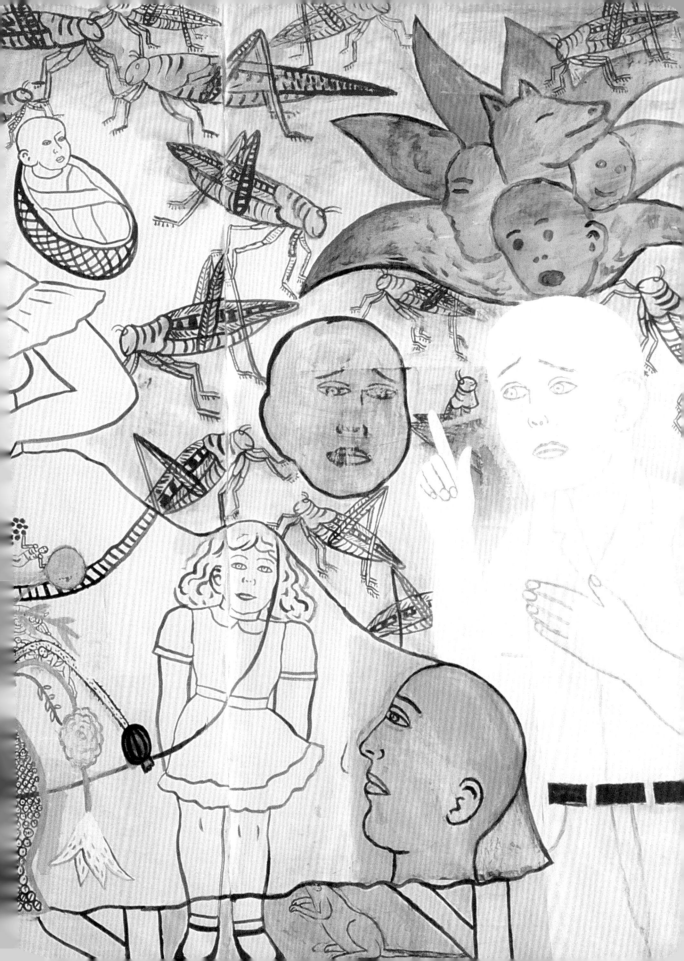

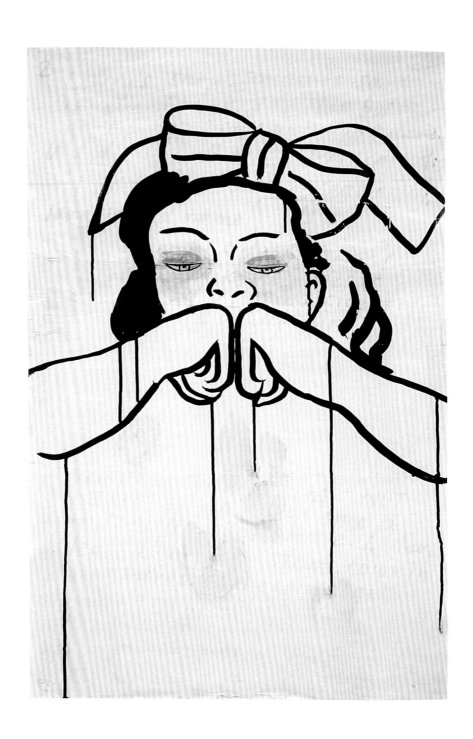

Sad, 1998

Little Worrier, 1998

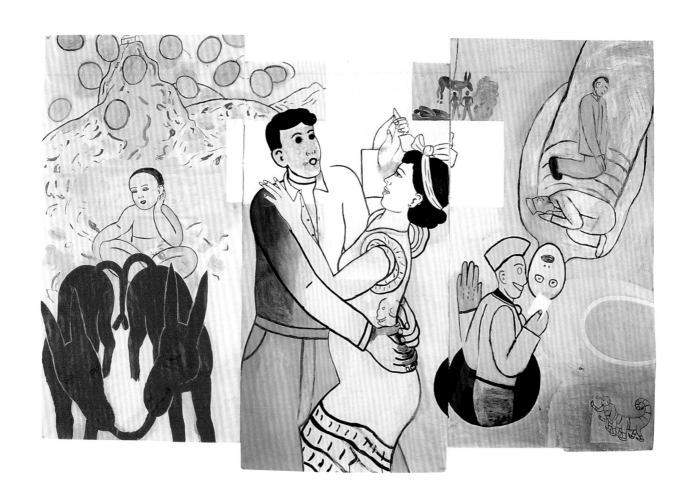

Dancing on the White House Lawn, 1998

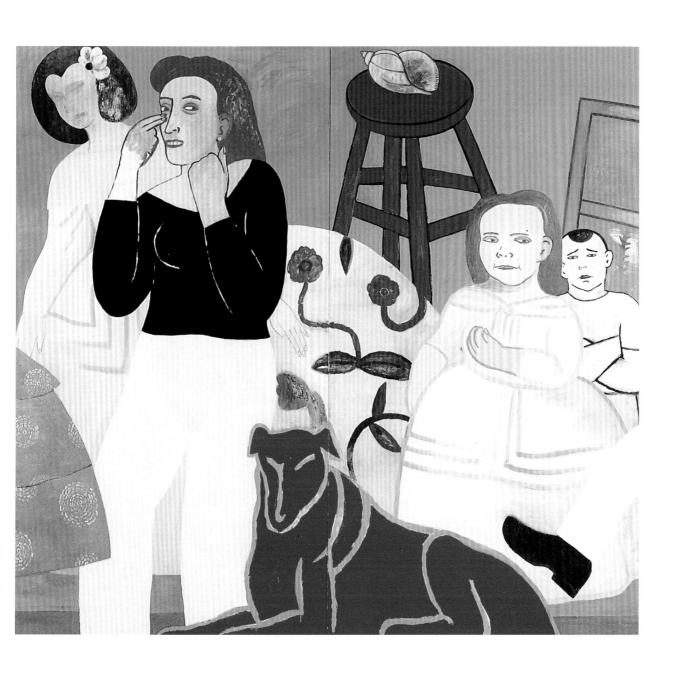

Handmaids, 1999

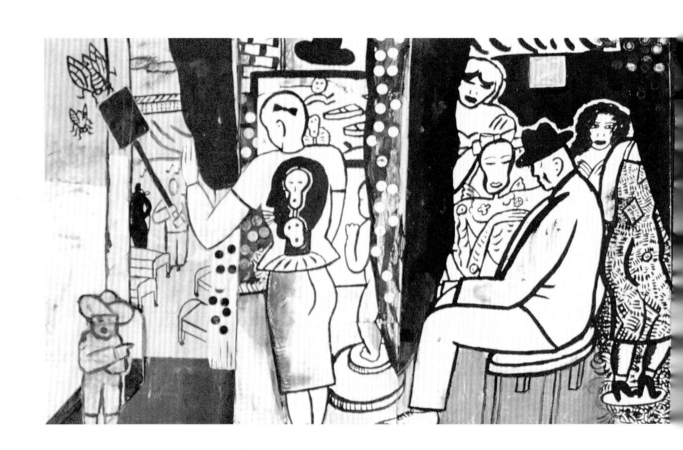

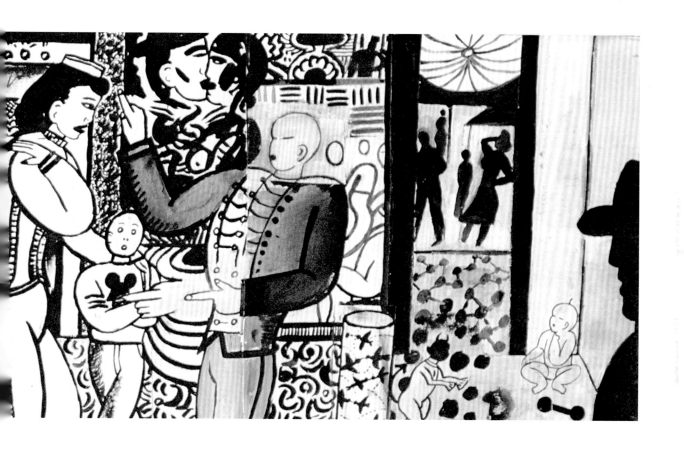

Full Length Feature, 1991

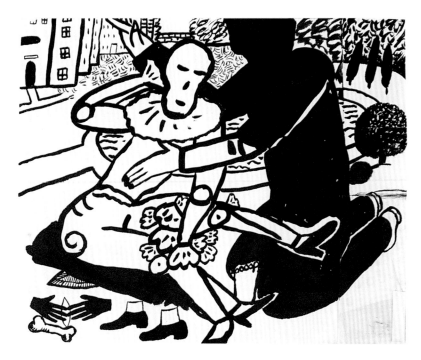

Accident, 1990

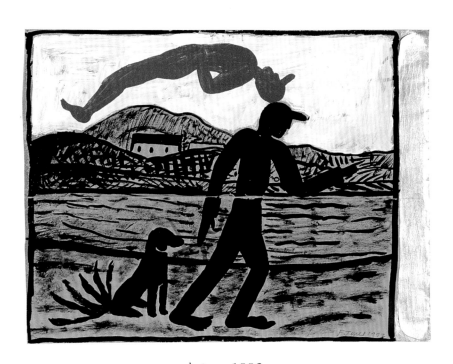

Animus, 1992

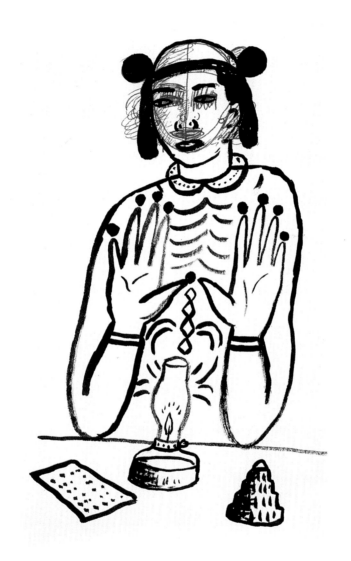

Notebook I #3, n.d.

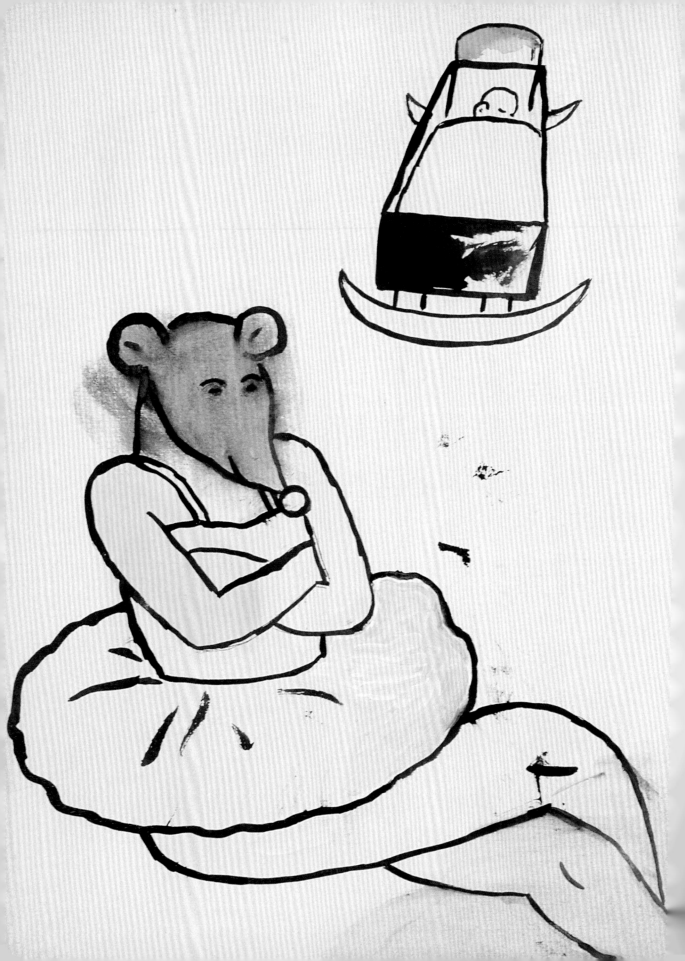

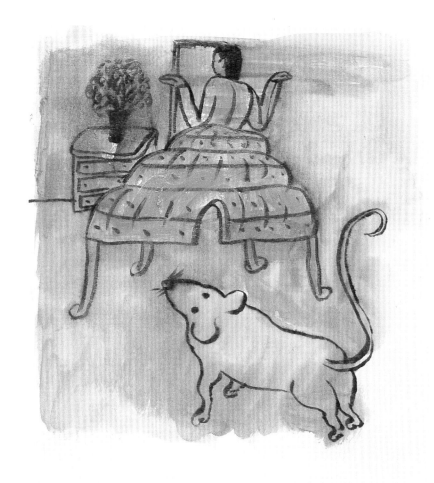

Notebook VIII #1, n.d.

Mouse Nanny, 1994

Notebook IV #6, n.d.

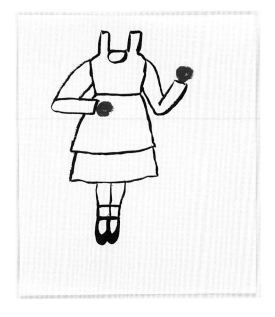

Notebook VIII #5, n.d.

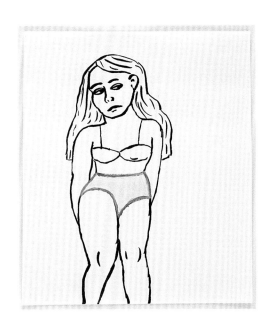

Notebook VIII #2, n.d.

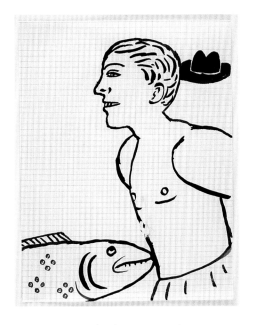

Notebook III #4, n.d.

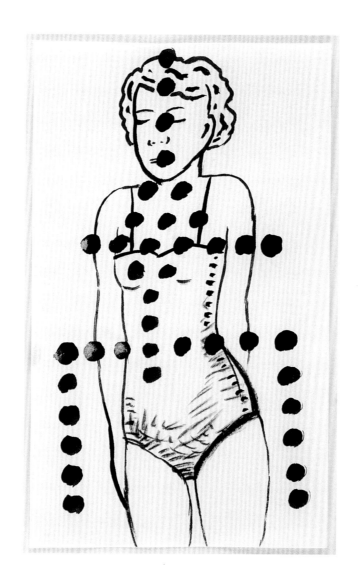

Notebook I #1, n.d.

List of Illustrations

All dimensions are in inches; height precedes width precedes depth. Unless otherwise indicated, all paintings are courtesy of the artist and Grover Thurston Gallery.

Page 1
Girl with Bunny & Skirt, 1999
Acrylic, sumi ink, and collage on paper; 25 × 33
Collection of Mr. and Mrs. Kenneth Novack

Page 2
Untitled, 1990
Acrylic and collage on paper; 49 × 37

Page 3 (also page 115)
Notebook I #3, n.d.
Ink and sumi ink on paper; 8¼ × 4¾
Collection of the artist

Pages 6–7
Hair, 1996
Acrylic and sumi ink on paper mounted on wood panel; 51¾ × 60
Collection of Douglas and Lila Goodman

Page 8
The Cart Beneath the Horse, 1991
Acrylic, sumi ink, and collage on paper; 21½ × 30½
Private collection

Pages 14–15
Caution, 1997
Acrylic and sumi ink on okawara paper; 73 × 76
Collection of Amanda and Max Lyon

Page 16
Dysphoria, 1997
Part 1 of 2; acrylic, sumi ink, and collage on paper; 44 × 115
Collection of Barbara and George Grashin

Page 17
Dysphoria, 1997
Part 2 of 2; acrylic, sumi ink, and collage on paper; 44 × 115
Collection of Barbara and George Grashin

Page 18
Dolce Far Niente, 1988
Acrylic, sumi ink, and collage on paper; 10¼ × 15
Private collection

Page 19
Diagnosis, 1997
Acrylic and sumi ink on paper; 32½ × 42¾
Collection of Geof Beasley and Jim Sampson

Pages 20–21
Two Pools: Riddle and Ghosts, 1992
Acrylic and collage on paper; 39 × 50
Collection of the artist

Page 22 (top)
Coat and Bones, 1997
Acrylic and sumi ink on paper; 10¼ × 14
Private collection

Page 22 (bottom)
Travel, 1999
Acrylic on paper mounted on wood panel; 25 × 33
Collection of Mary Ingraham and James Brown

Page 23
Meat, 1996
Acrylic and sumi ink on paper mounted on wood panel; 51¾ × 60
Collection of Carol Bobo

Page 24
Blue Monkey Dress, 1997
Acrylic and sumi ink on paper; 26 × 24¼
Collection of the Westin Portland Hotel, Oregon

Page 25
Monkey Dress, n.d.
Acrylic and collage on paper; 11 × 16½
Private collection

Page 26
Kneel, 1996
Acrylic, sumi ink, and collage on paper; 16 × 25¼
Collection of Ruth Miska

Page 27
Dress and Suit Adjacent, 1997
Acrylic on paper; 27½ × 39
Private collection

Page 28
Court Date, 1993
Monotype; 20¾ × 28
Collection of Bill and Dinah Deshler

Page 29
Swing, 1996
Acrylic and sumi ink on paper; 14 × 19
Collection of Francine and Benson Pilloff

Page 30
Contentment/Continue, 1994
Acrylic and sumi ink
on paper; 10 × 6½
Private collection

Page 33
From Notebook XIII
Sumi ink on paper; 6¼ × 9¼
Collection of the artist

Page 34 (top)
From Notebook IX
Acrylic and sumi ink
on paper; 9 × 14½
Collection of the artist

Page 34 (bottom)
From Notebook IX
Acrylic, sumi ink, collage,
and ink on paper; 9 × 14½
Collection of the artist

Page 35 (top)
From Notebook IX
Acrylic and sumi ink
on paper; 9 × 14½
Collection of the artist

Page 35 (bottom)
From Notebook IX
Sumi ink and collage
on paper; 9 × 14½
Collection of the artist

Page 36 (top)
From Notebook XII
Acrylic and sumi ink on
printed paper; 8½ × 11
Collection of the artist

Page 36 (bottom)
From Notebook XII
Acrylic and sumi ink on
printed paper; 8½ × 11
Collection of the artist

Page 37 (top)
From Notebook XII
Acrylic, sumi ink, and collage
on printed paper; 8½ × 11
Collection of the artist

Page 37 (bottom)
From Notebook XII
Sumi ink on printed paper;
8½ × 11
Collection of the artist

Page 38
Fog, 1995
Acrylic on paper; 39 × 37
Collection of David and
Michelle Hasson

Page 41
Gifts, 1992
Acrylic and sumi ink
on paper; 39 × 48½
Private collection

Page 43
Notebook III #1, n.d.
Acrylic and sumi ink
on paper; 10 × 7½
Collection of the artist

Page 44
Props, 1995
Acrylic and sumi ink
on paper; 18 × 15½
Private collection

Page 45
Meet, Sleep, 1996
Acrylic and sumi ink
on paper; 17¾ × 23½
Collection of M. J. Broquedis

Page 46
Silent Treatment, 1999
Acrylic on wood panel;
24 × 20
Collection of the artist

Page 47
Siblings, 1991
Acrylic and collage on paper;
18 × 21
Collection of George Chacona

Page 48
Mystery, 1997
Part 1 of 2; acrylic on
etching; 18 × 13½
Collection of Everett
and Margery Jassy

Page 49
Mystery, 1997
Part 2 of 2; acrylic on
etching; 18 × 13½
Collection of Everett
and Margery Jassy

Page 50
Little Pillow Mates, 1991
Acrylic and collage on paper;
10 × 12½
Collection of Susan Grover
and Richard Thurston

Page 51
Shades, 1997
Acrylic and sumi ink on paper
mounted on wood panel;
86 × 103
Private collection

Page 52
Lifting the Veil, 1994
Acrylic and sumi ink on
pink paper; 54 × 92½
Collection of the artist

Page 57
Gemini, 1998
Acrylic and sumi ink on paper
mounted on wood; 33¼ × 25
Collection of Erin McClelland

Page 58
Acrophobia, 1995
Acrylic and sumi ink on
paper; 27½ × 29
Collection of Francine
and Benson Pilloff

Page 59
Stack of Pallid Monkeys, 1998
Acrylic on paper mounted
on wood panel; 75 × 33
Collection of the artist

Page 60
Notebook V #2, 1994
Sumi ink on paper; 8¼ × 4¾
Collection of the artist

Page 61 (left)
Notebook II #1, n.d.
Acrylic, ink, and sumi ink
on paper; 7 × 4¼
Collection of the artist

Page 61 (right)
Notebook IV #4, n.d.
Sumi ink on paper; 8 × 5¼
Collection of the artist

Page 62
Notebook V #1, 1994
Sumi ink on paper; 8¼ × 4¾
Collection of the artist

Page 63 (top left)
Notebook IV #1, n.d.
Acrylic and ink on paper;
8 × 5¼
Collection of the artist

Page 63 (bottom left)
Notebook VIII #3, n.d.
Acrylic, ink, and collage
on paper; 6 × 5¼
Collection of the artist

Page 63 (top right)
Notebook XI #1, n.d.
Sumi ink and collage
on paper; 9 × 6¼
Collection of the artist

Page 63 (bottom right)
Notebook III #3, n.d.
Sumi ink on paper; 10 × 7½
Collection of the artist

Page 64
*Mann on Mountain, Hunter on
the Plain,* 1985
Acrylic, sumi ink, and collage
on paper; 27 × 39
Collection of Bradford Matsen

Page 67
Jane on the Road, 1985
Acrylic and collage on paper;
27 × 39
Collection of Don Koc and
Marty Hartrick

Page 68
Narcissi, 1997
Acrylic on okawara paper;
72 × 38¾
Courtesy of Kathleen and
Karl Krekow

Pages 72–73
Poppaea's Herd, 1997
Sumi ink on okawara paper;
73 × 117
Collection of Dorothy Cross
and Kerry Leimer

Pages 74–75
Nose, 1996
Acrylic and sumi ink on folded
okawara paper; 17 × 39
Collection of Helen Gamble

Page 76
Incongruous Weight, 1998
Acrylic, sumi ink, and collage
on paper; 50 × 27
Collection of Susan Grover
and Richard Thurston

Page 77
Queen's Bath, 1997
Acrylic and sumi ink on
okawara paper; 73 × 39
Collection of the artist

Pages 78–79
Stranded Bride, 1999
Acrylic on paper mounted on
wood panel; 33 × 50
Collection of Paul Schneider
and Lauren Eulau

Page 80
Embracing the Spectre, 1997
Acrylic, sumi ink, and collage
on okawara paper; 73 × 76
Collection of Carol I. Bennett

Page 84
Lone Tar, 1991
Acrylic on paper; 12 × 15¾
Collection of Sondra Shulman

Page 85
Smell, 1996
Acrylic and sumi ink on
paper; 32¾ × 43
Collection of Amanda Fin

Page 86
Strange Pursuit, n.d.
Acrylic and sumi ink
on paper; 9 × 14¼
Private collection

Page 87 (left)
Notebook IV #5, n.d.
Ink on paper; 8 × 5¼
Collection of the artist

Page 87 (right)
Compliance, 1991
Acrylic and collage on
paper; 15¼ × 11¼
Collection of Lisa Dutton
and Michael Spafford

Page 88
Sorrow, 1997
Acrylic and sumi ink on
okawara paper; 73 × 39
Private collection

Page 89
Beating Odds, 1998
Acrylic on paper mounted
on wood panel; 33¼ × 25
Collection of Sean Elwood
and Yvonne Puffer

Page 90
Wardrobe Interior, 1991
Acrylic on paper; 16 × 19
Collection of Dianne Anderson

Pages 95–97
Thrice Told Tales, 1993
Thirty-six parts; acrylic, sumi ink,
and collage on paper; 44 × 144
Collection of Arlene and
Harold Schnitzer

Page 98
Love Lies Bleeding (Amaranth), 1997
Acrylic and sumi ink on paper
mounted on wood; 68 × 52
Collection of Dr. and
Mrs. Lloyd Babler

Page 104
The Conductor, 1997
Edition of 50; spit bite and sugar
lift aquatint etching; 36 × 49
Publisher: Beta Press, Seattle

Page 105
Two Tureens, 1996
Acrylic on paper; 39½ × 53½
Collection of John and
Laurie Fairman

Pages 106–107
Dire Predictions, 1999
Acrylic and collage on paper;
70 × 109½
Collection of Dr. Herbert and
Shirley Semler

Page 108
Sad, 1998
Acrylic and sumi ink on paper;
32 × 21
Collection of Carol I. Bennett

Page 109
Little Worrier, 1998
Acrylic on paper; 30 × 22
Collection of Marc and
Charleen Kretschmer

Page 110
Dancing on the White House Lawn,
1998
Acrylic and sumi ink on okawara
paper; 77 × 108
Collection of Dr. Herbert and
Shirley Semler

Page 111
Handmaids, 1999
Acrylic on paper mounted on
wood panel; 90 × 96
Collection of Win McCormack

Pages 112–113
Full Length Feature, 1991
Acrylic, sumi ink, and collage
on paper; 10 × 34¼
Private collection

Page 114 (top)
Accident, 1990
Sumi ink on paper; 10 × 12
Collection of the artist

Page 114 (bottom)
Animus, 1992
Acrylic and sumi ink on
paper; 9½ × 12½
Collection of Jim and
Judy Wagonfeld

Page 115
Notebook I #3, n.d.
Ink and sumi ink on
paper; 8¼ × 4¾
Collection of the artist

Page 116
Mouse Nanny, 1994
Acrylic and sumi ink on
paper; 16 × 12
Collection of Ann Troutner

Page 117
Notebook VIII #1, n.d.
Acrylic and sumi ink on
paper; 6 × 5¼
Collection of the artist

Page 118 (top left)
Notebook IV #6, n.d.
Sumi ink on paper; 8 × 5¼
Collection of the artist

Page 118 (bottom left)
Notebook VIII #2, n.d.
Acrylic and sumi ink
on paper; 6 × 5¼
Collection of the artist

Page 118 (top right)
Notebook VIII #5, n.d.
Acrylic and sumi ink
on paper; 6 × 5¼
Collection of the artist

Page 118 (bottom right)
Notebook III #4, n.d.
Sumi ink on paper;
10 × 7½
Collection of the artist

Page 119
Notebook I #1, n.d.
Sumi ink on paper;
8¼ × 5
Collection of the artist

Biography

Education

1957 B.F.A., Rhode Island School of Design,
 Providence

Solo Exhibitions

2000 Grover/Thurston Gallery, Seattle (also 1998,
 1997, 1996)

1999 Salt Lake City Art Center
 Robischon Gallery, Denver
 Laura Russo Gallery, Portland, Ore. (also
 1997, 1994, 1992, 1988)

1998 Museum of Northwest Art, La Conner, Wash.

1997 *Drawings,* Kimura Art Gallery, University of
 Alaska, Anchorage

1996 *Fay Jones: A 20 Year Retrospective,* Boise Art
 Museum; Washington State University,
 Pullman; Seattle Art Museum

1993 Francine Seders Gallery, Seattle (also 1990,
 1989, 1987, 1985, 1982–83, 1981,
 1980, 1978, 1976, 1973, 1970)

1992 Sarah Spurgeon Gallery, Central Washington
 University, Ellensburg

1991 Shoshana Wayne Gallery, Los Angeles
 (also 1989, 1986)

1990 Whatcom Museum of History and Art,
 Bellingham, Wash.

1987 Spokane Falls Community College, Visual
 Arts Gallery, Spokane

1985 *Documents Northwest: Fay Jones,* Seattle
 Art Museum
 Portland Center for the Visual Arts, Ore.

1983 Brunswick Gallery, Missoula, Mont.

1979 Viking Union Gallery, Western Washington
 University, Bellingham

1974 Tacoma Art Museum

Group Exhibitions

1998 *A Generation Apart: Fay Jones and Karen Ganz,*
 Sun Valley Center for the Arts, Idaho

1997 SAFECO Collection, Jundt Museum,
 Gonzaga University, Spokane
 Curatorial Choice: A Northwest Survey, Holter
 Museum of Art, Helena, Mont.

1995 *Ex Libris,* Fisher Gallery, Cornish College of
 the Arts, Seattle
 The Curatorial Eye of James Archer, Archer
 Gallery, Clark College, Vancouver, Wash.
 Carved & Incised: Contemporary Block Prints,
 Whatcom Museum of History and Art,
 Bellingham, Wash.
 Washington: 100 Years, 100 Paintings, Bellevue
 Art Museum, Wash.

1994 *Tacoma Art Museum: Selections from the North-
 west Collection,* Seafirst Gallery, Seattle

1993– *Time Away,* selected prints from the Artist
1994 Residency Program of the Centrum Foun-
 dation, Tacoma Art Museum, Wash.

1993 *Tribute, in Remembrance of Dr. William Sawyer,
 1020–1003,* William Sawyer Gallery,
 San Francisco
 The Art of Microsoft, Henry Art Gallery,
 University of Washington, Seattle
 Two Person Show, Confluence Gallery,
 Twisp Community Gallery, Wash.
 Northwest Art: A Narrative/Figurative View,
 Valley Museum of Art, La Conner, Wash.
 Art Works for AIDS, Seattle Center Pavilion
 (also 1990)
 Annual Works of the Heart Exhibition, Cheney
 Cowles Museum, Spokane
 Seattle × 8: New Work, Seattle Art Museum
 Rental Sales Gallery
 *XX: An Exhibition on the Occasion of the
 Women's Caucus for Art National Conference,*
 Francine Seders Gallery II, Seattle

1992　*Water Works,* US West New Vector Group, Bellevue, Wash.

The Comedy of Art, Bumbershoot Festival, Seattle Center

Northwest Tales: Contemporary Narrative Painting, Anchorage Museum of History and Art; University of Alaska Museum and Fairbanks Arts Association Galleries; Alaska State Museum, Juneau

Multiples, Who We Are: Autobiographies in Art, Rotunda of the State Capitol, Olympia, Wash.

It Figures, The Human Image in Art, Index Gallery, Clark College, Vancouver, Wash.

1991– *Collaborators,* Tacoma Art Museum, Wash.;
1994 *Pleas and Thank Yous, True Stories,* Galleria Potatohead, Seattle; Western Gallery, Western Washington University, Bellingham; Port Angeles Fine Arts Center, Wash.; Cheney Cowles Memorial Museum, Spokane; Clatsop Community College, Astoria, Ore.; Salem College, Winston-Salem, N.C.; Boise Art Museum; Steensland Gallery, St. Olaf College, Northfield, Minn.; Art Department Gallery, University of Nebraska, Omaha

1991 *The Artist in the Art: Self-Portraits,* Bumbershoot Festival, Seattle Center

1991 National Governor's Association Annual Meeting Exhibition, Washington State Convention Center, Seattle

25th Anniversary Exhibitions: The Early Years 1966–1972, Francine Seders Gallery, Seattle

Celebrations & Ceremonies, Seattle Pacific Gallery

War in the Gulf: From an Artist's Perspective, William Traver Gallery, Seattle

Northwest Focus: Incisive Expressions, Museum of Art, Washington State University, Pullman

1990 *Bumbershoot Turns 20,* Bumbershoot Festival, Seattle Center

Views and Visions in the Pacific Northwest, Seattle Art Museum

Work Using Recycled Material, Francine Seders Gallery, Seattle

Northwest by Southwest: Painted Fictions, Palm Springs Desert Museum, Calif.; Yellowstone Art Center, Billings, Mont.; Western Washington State University, Bellingham; Sarah Campbell Blaffer Gallery, University of Houston

Warm Breezes, Winter Visions, Port Angeles Fine Art Center, Wash.

1989 *100 Years of Washington Art: New Perspectives,* Tacoma Art Museum, Wash.

Two Perspectives: Fay Jones & Elizabeth Sandvig, Cheney Cowles Museum, Spokane

Printmaking at Centrum, Port Angeles Fine Art Center, Wash.

Six Northwest Women Artists, Willamette University, Salem, Ore.

1988 *Celebration: Especially for Children,* Bellevue Art Museum, Wash.

Paper Works, North Seattle Community College Art Gallery

In Transit: The Concept of Transit in Art, Bumbershoot Festival, Seattle Center

Contemporary Survey: A Visible Presence in the Northwest, Cheney Cowles Memorial Museum, Spokane

1987 *Focus: Seattle,* San Jose Museum of Art, Calif.

Masks: A Contemporary Perspective, Whatcom Museum of History and Art, Bellingham, Wash.

Private Vision/Public Spaces, Bellevue Art Museum, Wash.

1986 *A Special Premiere Exhibition,* Laura Russo Gallery, Portland, Ore.

Northwest Impressions: Works on Paper, Henry Art Gallery, University of Washington, Seattle

The Artists and Art Forms, Henry Art Gallery, University of Washington, Seattle

10/40, Anniversary Exhibition, Bellevue Art Museum, Wash.

Figure: Narrative, Whatcom Museum of History and Art, Bellingham, Wash.

1985 *Seattle Painting 1925–1985,* Bumberbiennale, Seattle Center

Figuration: New Image, Invitational, Fountain Gallery, Portland, Ore.

Group Show, Bank of California Center, Seattle

1984 *Strange,* Invitational, Henry Art Gallery, University of Washington, Seattle

36th Annual Academy and Institute of Arts and Letters Purchase Exhibition, New York

Northwest Art from Corporate Collections, Waterfront Park, Seattle

1983　*Contemporary Seattle Art of the 1080s,* Bellevue Art Museum, Wash.

Bumberbiennale, Northwest Rooms, Seattle Center

Outside New York: Seattle, The New Museum, New York

Two Person Show, Seattle Pacific University

1982　*Three from Seattle,* William Sawyer Gallery, San Francisco

Women and the Environment, Gallery of Visual Arts, University of Montana, Missoula

Artworks: Seattle, Bumbershoot Festival, Seattle Center

Introduction '82, Fountain Gallery, Portland, Ore.

Ten Northwest Women Artists, University of Washington Women's Information Center, Seattle

Pacific Northwest Drawing Perspectives, Eastern Washington University, Cheney, Wash.

1981　*Northwest Collections,* Henry Art Gallery, University of Washington, Seattle

A Woman's Place, John Michael Kohler Arts Center, Sheboygan, Wis.

Seattle × 8, Open Space Gallery, Seattle

Seattle Drawings: An Invitational Exhibit, Seattle Pacific University

The Mind's Eye: Expressionism, Henry Art Gallery, University of Washington, Seattle

Invitational Group Exhibition, Spokane Community College

Seattle Women Artists, The Gallery, Spokane Falls Community College, Spokane

1980　*Contemporary Washington State Artists,* The Cranberry Gallery, Plymouth, Mass.

The Artist as Magus, The Women's Building, Los Angeles

Northwest Artists: A Review, Seattle Art Museum

Three Person Show, Olympic College, Bremerton, Wash.

1979　*Governor's Invitational,* State Capital Museum, Olympia, Wash. (also 1970)

Washington Open, Seattle Art Museum

Contemporary Art from Washington, Cranberry World Visitors Center, Plymouth, Mass.

1978　*Northwest Collectibles,* Weyerhaeuser Headquarters, Federal Way, Wash. (presented by the Seattle Art Museum)

The City Collects II, Seattle Arts Commission 1 Percent for Art Program

1977　*Robert C. Jones/Fay Jones,* Adlai Stevenson College Library, University of California, Santa Cruz

Northwest '77, Seattle Art Museum

Seattle Walls Project, Seattle Arts Commission

1976　*Women in the Arts,* Seattle Center

Landscapes, Francine Seders Gallery, Seattle

1975　*Birds, Beasts and Monsters,* Francine Seders Gallery, Seattle

1974–　Francine Seders Gallery, Seattle
1975

1974　*Paintings, Drawings and Ceramics by Northwest Artists,* Francine Seders Gallery, Seattle

1973　*Landscape Elements,* Henry Art Gallery, University of Washington, Seattle

Fay Jones, Gary Lundell, Robert Wilson, Francine Seders Gallery, Seattle

1972　*Survivors 1972,* Henry Art Gallery, University of Washington, Seattle

Five in May, Ellensburg Community Gallery, Wash.

Fay Jones, Elizabeth Sandvig, Tom Prochaska, Francine Seders Gallery, Seattle

1970–　*Symbols and Images,* American Federation of
1972　　Arts Traveling Exhibition

Awards, Grants, Honors, and Residencies

2000　Artist in Residence, Pilchuck Glass School, Stanwood, Wash.

1993　Artist in Residence, Centrum Foundation, Port Townsend, Wash. (also 1987)

1992　Printmaking Residency, University of Nebraska, Omaha

Printmaking Residency, Pilchuck Glass School, Stanwood, Wash.

1990　National Endowment for the Arts, Individual Artist Fellowship Grant

1989　Two-month study grant from La Napoule Art Foundation administered through Artist Trust

1984　Individual Artist Fellowship Grant, Washington State Arts Commission

1983　National Endowment for the Arts, Visual Artist Fellowship Grant

Selected Public and Corporate Collections

Boise Art Museum
Cheney Cowles Memorial Museum, Spokane
Davis Wright Tremaine, Seattle
Foster Pepper & Shefelman, Seattle
King County Arts Commission, Seattle
Leimer Cross Design, Seattle
Lorig and Associates, Seattle
Microsoft Corporation, Redmond, Wash.
Municipal Collection of the City of Seattle
Portland Art Museum, Ore.
Psychoanalytic Institute, Seattle
Reed, McClure, Moceri and Thonn, Seattle
Seafirst Bank, Seattle
Seattle Art Museum
Seattle Opera House
Stoel, Rives, Boley, Jones and Grey, Seattle
Tacoma Art Museum
University of Washington Medical Center, Seattle
Vesti Corporation, Boston
Washington Schools Art Collection; Washington
 State Arts Commission
Women's Health Care Clinic, Inc., Seattle

Commissions

Earshot Jazz Festival Poster
Bumbershoot Festival Poster, City of Seattle
Seattle Arts Commission
Seattle Walls Project, Seattle
US West NewVector Group poster and lithograph,
 Bellevue, Wash.
Westlake Station Mural, Metro Transit, Seattle

Bibliography

1998 Hackett, Regina. "Jones' Color Has Airy
 Charm." *Seattle Post-Intelligencer*, Nov. 13.
 Updike, Robin. "Tales of Truth and Desire."
 Seattle Times, Nov. 5.
 Farr, Sheila. "Keeping Up with the Joneses."
 Seattle Magazine, Nov.
 Updike, Robin. "North's the Direction to go
 for Adventurous Art Lovers." *Seattle Times*,
 May 11.
 Walbeck, Nancy. "Spring Brings Smile to
 MoNA." *Anacortes American*, May 8.
 Smith, Tracy A. "Fay Jones at Laura Russo."
 Art in America, May.

1997 Updike, Robin. "Donkey Milk and Hubris."
 Seattle Times, May 8.
 McTaggart, Tom. "Awfully Nice Pictures."
 The Stranger, Apr.
 Campbell, R. M. "Fay Jones' Life Starting Point
 for Her Vibrant, Intimate Work." *Seattle Post-
 Intelligencer*, Mar. 26.
 Farr, Sheila. "Behind the Masks." *Seattle Weekly*,
 Mar. 26.
 Updike, Robin. "Humor and Shadows." *Seattle
 Times*, Mar. 20.

1996 Harthorn, Sandy. *Fay Jones: A 20 Year Retro-
 spective*. Boise, Idaho: Boise Art Museum.
 Schnoor, Chris. *Aorta*, Oct./Nov.
 ———. "An Act of Fay." *Boise Weekly*, Sept. 12.
 Burkman, Greg. "The Language of Fay Jones."
 Artifact, Sept./Oct.
 Hackett, Regina. "It Is No Stroke of Luck That
 Brings Fay Jones to Prominence." *Seattle
 Post-Intelligencer*, Apr. 17.
 Updike, Robin. "Artwork in April." *Seattle
 Times*, Apr. 12.
 Updike, Robin. "Painter of Dreams: Fay Jones
 Creates a Unique World." *Seattle Times*, Apr.

1995 Allan, Lois. *Contemporary Art in the Northwest*.
 Roseville East, Australia: Craftsman House.
 Ross, Terry. "Summer All-Stars, Summer Not."
 The Oregonian, July 12.
 Hackett, Regina. "Books Take a Variety of
 Shapes in Artists' Hands." *Seattle Post-
 Intelligencer*, Jan. 16.
 Frederickson, Eric, and Brad Steinbacher.
 "Highbrow Reviews: Artists' Books and a
 Booker Prize Winner." *The Stranger*,
 Jan. 10–16.

1994 Ross, Terry. "The Clashing of Symbols." *The Oregonian,* Nov. 13.

1993 Bruce, Chris. *The Art of Microsoft.* Seattle: Henry Art Gallery, University of Washington.

Brunsman, Laura, and Ruth Askey. *Modernism and Beyond, Women Artists of the Pacific Northwest.* New York: Midmarch Arts.

McLerran, Jennifer. "Narrative and Figurative Trends: Telling Differences."

Hackett, Regina. "A NW Tribute: The Art of Microsoft." *Seattle Post-Intelligencer,* July 1.

Berger, David. "Art Friendly Microsoft May Be the Region's Most Surprising Patron." *The Seattle Times/Pacific,* June 27.

Keeley, Pam. "Fay Jones at Francine Seders Gallery." *Reflex,* Mar./Apr.

Hackett, Regina. "Fay Jones' Paintings Read Like Novels." *Seattle Post-Intelligencer,* Feb. 22.

———. "Individualist's Styles Share the Spotlight in Show of Women Artists." *Seattle Post-Intelligencer,* Jan. 19.

1992 Hutton, Jean. "Fay Jones at Laura Russo Gallery." *Reflex,* Mar./Apr.

Pate, Suzanne. "Art Show Tells 100 True Stories of Personal Dreams." *The Spokesman Review-Spokane Chronicle,* Mar. 6.

Ingram, Jan. "Northwest Narrative Artists Are Good Story in Themselves." *Anchorage Daily News,* Feb. 23.

Gragg, Randy. "Hit Parade, Latest Works Display Fay Jones' Continuing Strength." *The Oregonian,* Feb. 14.

———. *The Oregonian,* Feb. 5.

Cover art, *Reflex,* Jan./Feb.

1991 Domini, John. "Tides of Change, Art of the Pacific Northwest." *Antiques & Fine Art,* Sept./Oct.

Hackett, Regina. "Seders' 25th Anniversary Show Starts off with a Sterling Exhibit." *Seattle Post-Intelligencer,* May 16.

———. "'Celebrations & Ceremonies' Lifts the Veil from Wedded Bliss." *Seattle Post-Intelligencer,* May 8.

———. "Tacoma Art Museum Scores with Exhibit of Teamwork." *Seattle Post-Intelligencer,* Apr. 17.

Raether, Keith. "The Art of Collaboration." *Morning News Tribune,* Apr. 14.

Mathieson, Karen. "War Within and Without." *The Seattle Times,* Mar. 7.

Carlsson, Jae. "Fay Jones, Whatcom Museum." *Artforum International,* Feb.

1990 *Art Works for AIDS.* Seattle: Seattle Center Pavilion.

Johns, Barbara. *Modern Art from the Pacific Northwest in the Collection of the Seattle Art Museum.* Seattle: Seattle Art Museum.

Lane, Bob. "Tunnel Station Opens to Raves." *The Seattle Times.*

Northwest by Southwest: Painted Fictions. Palm Springs, Calif.: Palm Springs Desert Museum.

Northwest Originals, Washington Women and Their Art. Portland, Ore.: MatriMedia.

Kangas, Matthew. "Stories of Our Lives." *The Weekly,* Oct. 17.

Farr, Sheila. "Seattle Painter Freezes Drama into an Instant." *Bellingham Herald,* Sept. 30.

Smallwood, Lyn. "Fetching Etchings." *The Weekly,* May 9.

———. "Fainter Paint." *The Weekly,* Mar. 14.

Hackett, Regina. "Fay Jones Has Dreamed Up a Painting Style All Her Own." *Seattle Post-Intelligencer,* Mar. 13.

Tarzan Ament, Deloris. "Jones' Collage Technique Builds Layers of Meaning." *Seattle Times,* Mar. 9.

"NEA Visual Arts Fellowships: Northwest Recipients." *Artist Trust,* Mar.

Turner, Priscilla. "Sob Story." *Alaska Airlines Magazine,* Mar.

Hackett, Regina. "An NEA Working Creative Magic." *Seattle Post-Intelligencer,* Feb. 13.

1989 Kingsbury, Martha. *Celebrating Washington's Art and Centennial Year Exhibition Guide.* Olympia, Wash.: 1989 Washington Centennial Commission.

Bryant, Elizabeth. "The Desire to Connect." *Reflex,* Nov./Dec.

Hosack, Kathy. "These 'Two Perspectives' Are Well Worth Sharing." *Spokane,* Nov. 12.

"Tunnel Vision." *Seattle Times/Post-Intelligencer,* Aug. 7.

Hammond, Pamela. "Fay Jones." *ArtNews.* May.

"Artist Trust Visual Artist for Residency at La Napoule in France." *Artist Trust,* Spring.

J. P. "Dix Jeunes Artistes en Residence Printemps." *Nice Matin,* Mar. 20.

Kangas, Matthew. "Fay Jones at Francine Seders." *Art in America,* Mar.

1987 Berger, David. "Fay Jones' Palette Produces Dreamy, Complex Images." *The Seattle Times,* Sept. 30.

Smallwood, Lyn. "Fay Jones Tales an Abstract, Poetic Turn." *Seattle Post-Intelligencer,* Sept. 15.

1986 Hackett, Regina. "Exhibit in San Jose Spotlights Seattle Art." *Seattle Post-Intelligencer,* Dec. 19.

Berkson, Bill. "Report from Seattle, In the Studios." *Art in America,* Sept.

Connell, Joan. "Exhibit Lets Figures Tell Stories." *Bellingham Herald,* Feb. 2.

1985 Joseph, Nancy. "Fay Jones at the Francine Seders Gallery." *Vision,* Fall.

"New Acquisition." *Portland Art Association,* Aug.

"Books in a College Matrix." *Signature,* July (complimentary anniversary issue).

Hackett, Regina. "The Words Get in the Way of these Collages." *Seattle Post-Intelligencer,* June 14.

Berger, David. "Stories from the Past." *Artweek,* Mar. 23.

———. "Jones Paints Life in Vivid, Curious Vignettes." *The Seattle Times/Post-Intelligencer,* Mar. 10.

Smallwood, Lyn. "Visual Arts: Fay Jones Emerges." *The Weekly,* Mar. 6–12.

"New Paintings by Jones at Seattle Art Museum." *Art Stars,* Mar.

Hackett, Regina. "Fine Coloration Carries the Day for Fay Jones' Paintings." *Seattle Post-Intelligencer,* Feb. 25.

Hayakawa, Alan R. "Content Is Back: Much Else Is Absent." *The Oregonian,* Feb.

1984 *Strange.* Seattle: Henry Art Gallery, University of Washington.

Smallwood, Lyn. "Strange and Wonderful." *The Weekly,* Nov. 28–Dec. 4.

Berger, David. "If It Seems 'Strange' Think About It." *Seattle Times,* Nov. 16.

Hackett, Regina. "'Strange': Odd Is in at UW's Henry Art Gallery." *Seattle Post-Intelligencer,* Nov. 16.

Moorman, Margaret. "Artists the Critics Are Watching." *ArtNews,* Nov.

1983 Guenther, Bruce. *50 Northwest Artists.* San Francisco: Chronicle Books.

Lippard, Lucy. *Overlay, Contemporary Art and the Art of Prehistory.* New York: Pantheon Books.

Rifkin, Ned. *Outside New York: Seattle.* New York: The New Museum; Seattle: Seattle Art Museum.

"Six Women Artists." *Seattle Woman,* Dec.

Smallwood, Lyn. "Seattle Art from New York City." *The Weekly,* Oct. 26.

Hackett, Regina. "Paul Berger's Photos Packed with Meaning." *Seattle Post-Intelligencer,* Oct. 20.

Kendall, Sue Ann. "Home Is Where the Art Is." *Seattle Times,* Oct. 13.

Hackett, Regina. "Snubbed in N.Y.: Seattle Art Show Gets No Respect." *Seattle Post-Intelligencer,* Oct. 12.

Maxwell, Jessica. "Oyster Light: The Renaissance of Seattle Art." *United Airlines Magazine,* Oct.

Smallwood, Lyn. "The Return of the Imagists." *The Weekly,* Apr. 27.

Hackett, Regina. "3 Artists: Pleasurable Still Lifes, Emotions in Color and Wild Dogs." *Seattle Post-Intelligencer,* Apr. 22.

1982 *The Washington Year: A Contemporary View, 1980–81.* Seattle: Henry Art Gallery, University of Washington.

Kendall, Sue Ann. "Love and Death Play 'the Game' in Show." *Seattle Times,* Dec. 26.

Hackett, Regina. "Artists Picked for N.Y. Show." *Seattle Post-Intelligencer,* Dec. 22.

1981 *A Woman's Place.* Sheboygan, Wis.: John Michael Kohler Arts Center.

Dike, Patricia. "Women Artists Share Visions." *The Spokesman Review,* May 17.

1980 Hackett, Regina. "Raising a Few Hackles Amid Show's Pleasures." *Seattle Post-Intelligencer,* June 8.

Lumbard, Paula. "News and Reviews." *Spinning Off,* Mar.

Campbell, R. M. "An Air of Violence and Tension." *Seattle Post-Intelligencer,* Feb. 29.

1979 Borter, Susan. "Fay Jones Creates Her Own
 Fantasies." Oct.
 Campbell, R. M. "A Lot of This and That."
 Seattle Post-Intelligencer, July 27.

1978 Tarzan, Deloris. "Fine Shows in 'Final Days'."
 Seattle Times, Apr. 25.
 Campbell, R. M. "Jones Work Not as It Seems."
 Seattle Post-Intelligencer, Apr. 23.
 Shere, Charles. "Gallery-Going in the North-
 west." *Oakland Tribune,* Jan. 29.

1977 Shulman, Sondra. *Fay Jones.* Seattle: Francine
 Seders Gallery.
 Schnoor, Chris. "An Eye for Inner Forces."
 Reflex, Nov./Dec.
 "Warshal's Mural." Art in Public Places #2,
 Seattle Arts, May.

1976 Campbell, R. M. "A Trio of Solo Exhibitions."
 Seattle Post-Intelligencer, Oct. 8.
 Tarzan, Deloris. "Figures Show Fantasy, Process
 at Seders, Manolides, Matheson." *Seattle
 Times,* Oct. 5.

1975 Orlock, Carol. "Paintings, Drawings and
 Ceramics by Northwest Artists." *Artweek,*
 Jan. 4.

1972 McG, Joy. "New Show at Art Gallery." *Ellensburg
 Daily Record,* May 8.

1970 Koenig, John Franklin. *Northwest Art from
 Corporate Collections.* Seattle: Seattle Parks
 Centennial Commission.
 Voorhees, John. "Acrylics, Sculpture Work
 Well at Seders." *Seattle Times,* Nov. 10.

ISBN: 0-295-98075-3
Library of Congress Control Number: 00-135351

Distributed by
University of Washington Press
P.O. Box 50096
Seattle, WA 98145

Front cover: *Bruise,* 1998, acrylic on paper,
19 × 27¾ inches. Collection of Ed Marquand
Back cover: *Cold Water's Edge,* 1998, acrylic and
sumi on paper, 78 × 102 inches. Collection of
Barbara Billings and Ernest Vogel
Page 124: Fay Jones, 2000. Photo by Eduardo
Calderón

The author gratefully acknowledges Random House for
permission to reproduce "Musée des Beaux Arts," from
W. H. Collected Poems by W. H. Auden. Copyright ©
1940 and renewed 1968 by W. H. Auden. Reprinted
by permission of Random House, Inc.

Unless otherwise indicated all photographs are © 2000
by Eduardo Calderón, except page 64 © 1985 by Chris
Eden and pages 30, 47, and 50 unknown.

Designed by Ed Marquand

Produced by Marquand Books, Inc., Seattle
 www.marquand.com

Printed and bound by C&C Offset Printing Co., Ltd.,
Hong Kong